# High Relief Wood Carving

# High Relief Wood Carving

## William J. Schnute

**Sterling Publishing Co., Inc.**
New York

Library of Congress Cataloging in Publication Data

Schnute, William J.
  High relief wood carving.

  Includes index.
  1. Wood-carving.  I. Title.
TT199.7.S36     1985     736'.4     84-26765

10  9  8  7  6  5  4  3  2  1

Published by Sterling Publishing Company, Inc.
387 Park Avenue South, New York, N.Y. 10016
The original edition of this book was published under
the title *High Relief Wood Carving*
© 2000 by William J. Schnute
Distributed in Canada by Sterling Publishing
% Canadian Manda Group, One Atlantic Avenue,
Suite 105
Toronto, Ontario, Canada M6K 3E7
Distributed in Great Britain and Europe by Cassell PLC
Wellington House, 125 Strand, London WC2R 0BB,
England
Distributed in Australia by Capricorn Link (Australia)
Pty Ltd.
P.O. Box 6651, Baulkham Hills, Business Centre, NSW
2153, Australia
*Printed in China*
*All rights reserved*

Sterling ISBN 0-8069-9336-7

# ACKNOWLEDGMENTS

Years ago Doctors Mark and Louise Dick returned from medical meetings in Germany with a set of carving knives and gouges. These tools proved that wood carving was considered a serious occupation, at least in some areas of the world.

It appears that many individuals who pursue unusual careers are the progeny of medical families and I am immensely grateful to my father, an orthoepedic surgeon, and mother, a civic innovator and promoter *par excellence*, for the range of experiences and advantages I enjoyed while growing up.

I need to thank Joan for the years of patience and sacrifice during the formative years of this learning process.

# CONTENTS

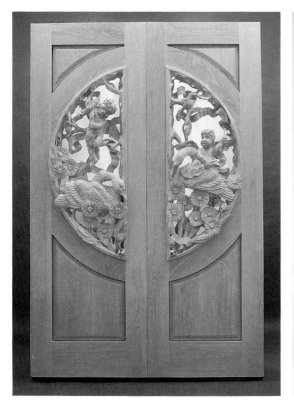

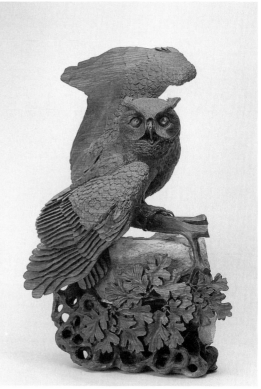

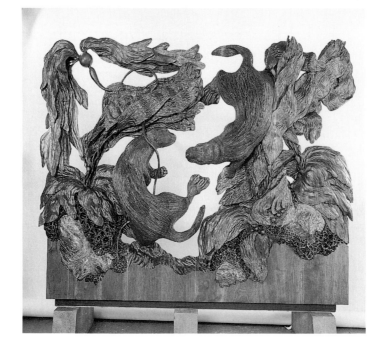

# *I*NTRODUCTION

Talking with other sculptors usually reveals common traits. These include the abilities to visualize mentally in three dimensions, to look at these images from different perspectives and make changes at will, and to combine these images with the sculptor's memories, emotions, and fears. There can be a fusion then between the mind and tools, transforming one's idea into a tangible substance, in this case, wood. If in this process an object of value is created, so much the better. A person is indeed fortunate to discover what he or she can do best, especially if a career or hobby can be created with that skill.

This book displays a body of work produced over an extensive period of time and attempts to explain the lessons and techniques learned from each project.

# 1 THE WOOD CARVING STUDIO

A studio can be anything from a three-blade knife and a block of wood to a spacious, fully equipped workshop. It is not so much the place as it is the experience and the result. Individual circumstances usually determine what is best, but to produce the body of work shown in this book, an efficient and well-equipped shop and studio were necessary.

To many people, wood carving implies the use of hand tools of all kinds, including gouges forged and tempered by the carver as they are needed (Illus. 1-1) until 50 to 100 are accumulated, as well as a block plane, clamps, sharpening stones for each gouge, and at least on good bench.

In wood sculpture, more emphasis is given to the design idea and how it translates to wood than to the methods used to achieve the final result. Power tools, considered suitable for beginners, are used with abandon to achieve the desired results. The advantages of using power tools are best illustrated by the two clocks shown in Illus. 1-2 and 1-3. It took almost six hours to hand-trim and -sand the rectangular case shown in Illus. 1-2, but the same results could be obtained with a table sander in ten minutes. A table sander was used on the clock shown in Illus. 1-3, and the time saved allowed the addition of a more graceful curved top and cutout windows,

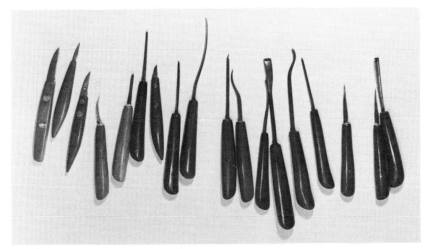

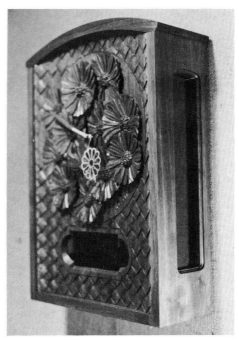

Illus. 1-2                                                    Illus. 1-3

which are usually of both leaded stained and clear glass, so that the beautiful clockworks could be seen.

Not surprisingly, workplaces can differ in setup, depending on their location and purpose. The studio described in the following pages was part of a home in which a lifestyle that emphasized privacy and autonomy was created. A very similar study (Illus. 1-4) was established in a retail place accompanied by a gallery to show completed works. This daily contact with the public can be invigo-

Illus. 1-5 and 1-6. A large studio full of tools is definitely not necessary to complete a wide variety of projects. A few carving knives, a card table, and spare time produced these walnut examples. Starting with a solid 10½" × 24" × 2" board, the Valley Oak Branch is completely undercut and attached at only a few points. This type of multi-layered carving gave the studio, Oak Leaves Studio, its name.

Illus. 1-4. Author's studio with gallery that is open to the public.

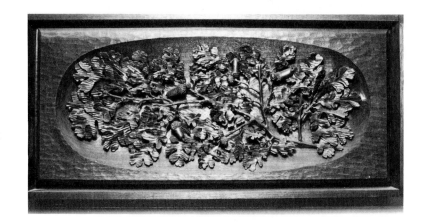

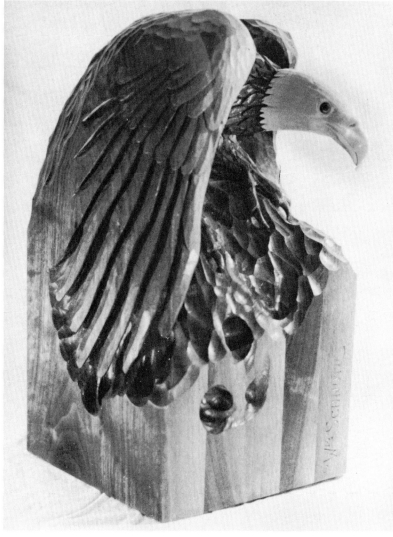

Illus. 1-7. The sperm whale tooth was carved with dental tools, and the block of wood for the eagle's body was glued together by using the weight of a car as a press because of a lack of any other equipment.

15

**Illus. 1-8.** My six-month-old-daughter Christine was the model for this 12″ × 12″ × 2″ carving. The technique for carving basket weave, now a studio hallmark, was developed on this carving.

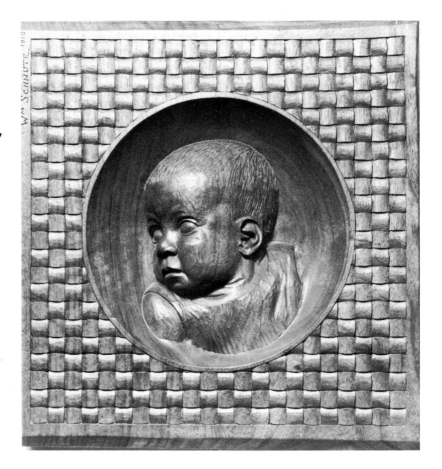

**Illus. 1-9.** The hydraulic base unit from an old surgery table has proved to be a most useful and back-saving tool. The table can be adjusted 10 inches up or down, tilted side to side 45 degrees, or adjusted to within a few inches perpendicular to the ground. Tilting allows easy access to the center of large panels and standing on a project upright allows correction to be made for lighting and perspective.

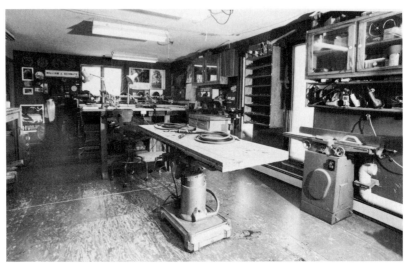

rating at times, but there are clashes between the attempts of a very private artist to ensure his privacy and his constant exposure to a viewing public.

The organization of the studio (1-10) helps the flow of a project from start to finish. Wood brought in from the kiln or wood storage area can be cut to length on the radial arm saw (A), ripped to width on the band saw (B), surfaced on the thickness planer (C), and edged on the jointer (D). Bar clamps (E) and C-clamps (F) are convenient to the table for glue-up (G). Tools in this area are con-

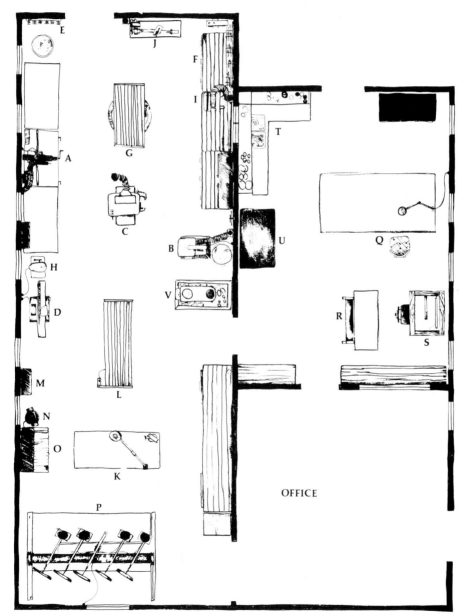

Illus. 1-10. Layout of the studio.

nected to a central vacuum located in the wood storage area. The drill press (H), sanding table (I), and a metal lathe (J) are also here. After glue-up and initial rough trimming, the block of wood is transferred to the carving bench (K) or the converted hydraulic surgery table (L). Approximately 200 carving gouges (M), a bench grinder with a felt wheel (N), and a bench for sharpening stones (O) are close at hand. Adhesives, hand and power tools, and safety equipment are also conveniently located in cabinets or on wallboards. Each side of the room has 110- and 220-volt outlets and the larger equipment and floor outlets are on separate circuit breakers. A four-spindle duplicator (P) is at the far end of the area. This tool is not really needed at a time when it is more cost-effective to have an outside source that utilizes laser-imaging scanners and computer-controlled computer machines that do the duplication.

The clean area has a 4 × 8-foot tilt-up drawing table (Q), drafting table (R), and light table (S) for tracing and slide work. A wide variety of stains, varnishes, and oils (T) are stored over the sink. Solvents are stored in a steel storage locker (U). The entire studio area is heated with the wood burning stove (V) with hot-water heat back-up.

Two necessary accessories, located in an adjacent entry to the studio, are an efficient vacuum system (Illus. 1-11) and an air compressor (Illus 1-12). Because the studio is located in an area without 3-phase service the capacity of some equipment is somewhat limited. The 1-and-one-half horsepower vacuum is adequate for all equipment except the duplicator.

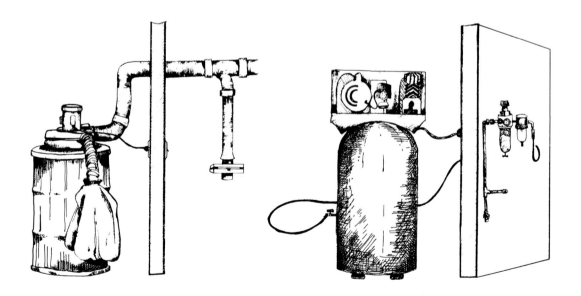

**Illus. 1-11. A vacuum system.**  **Illus. 1-12. An air compressor.**

# 2 DEVELOPMENT OF HIGH RELIEF PANELS

The maximum practical thickness of lumber which can be uniformly dried is about 3 inches, so instead of edge-gluing thick boards together, face gluing and edge gluing thinner but wide boards is my standard practice to make larger blocks of wood. Because a large volume of wood is needed for this process, a combination of edge-gluing boards to form the main panel and face-gluing additional layers of wood, where needed, has turned into an effective way to produce dramatic panels with elements of the design starting within the base layer and continuing outward from the panel. This type of panel is useful for making doors.

All of the grandeur of architecture is focused and reduced to the human scale at the point of entry to a structure. It is difficult to understand why this space is usually filled with a nondescript panel or a transparent pane of glass. A door can be thought of as an interface, a separation of the inside from the outside and as such, it should introduce and say something about the interior and the personalities within.

A series of wildlife habitat doors produced at our studio is designed to fulfill these requirements and also tries to reflect the

Illus. 2-1

Illus. 2-2

20

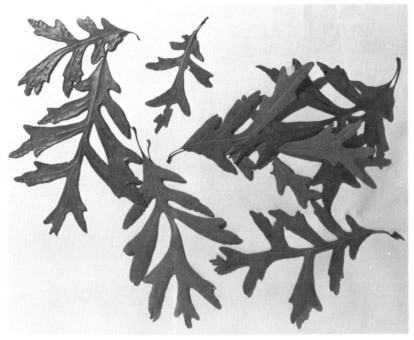

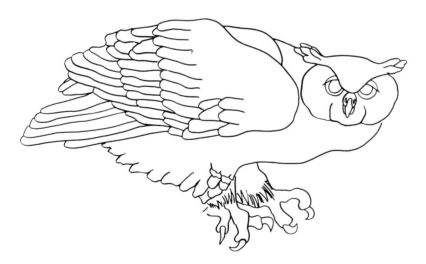

surprise the visitor feels when approaching such a door by carving each animal as if caught by surprise and at the instant before escape.

The first of this series was the owl door and its design features high relief carved oak, subtle staining and color, and stained glass. Depending on the time of day, front-lighted detail changes to silhouette and shadows.

Owls are regularly heard and occasionally seen from the studio

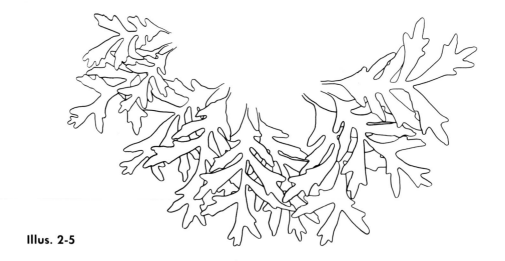

Illus. 2-5

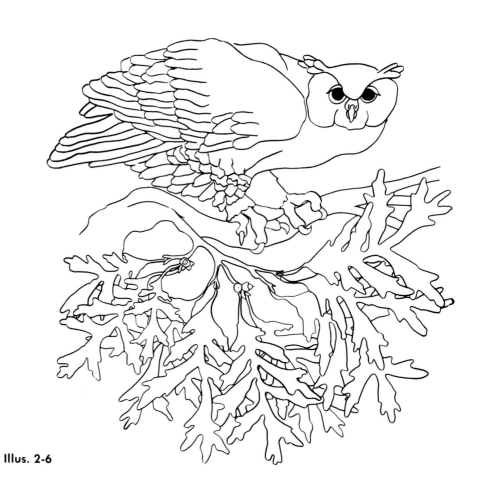

Illus. 2-6

A

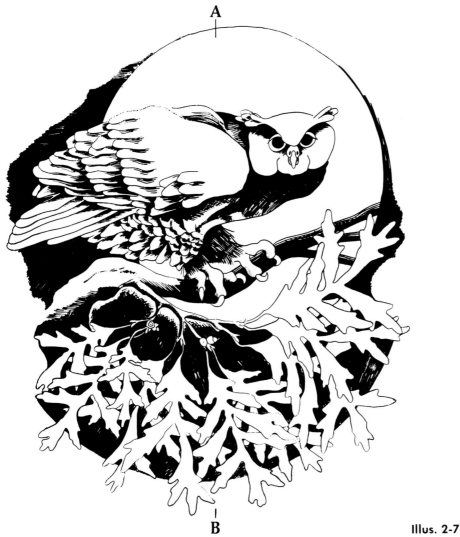

B

Illus. 2-7

windows. It seems fitting that this particular door is the front entrance to the studio.

Using a collection of photographs taken in the wild, at zoos, and from the study collection of mounted birds from the University of Iowa Natural History Museum (Illus. 2-1, 2-2, 2-3), an initial drawing of a threatened, fight or flight position was sketched on a sheet of tracing paper (Illus. 2-4). This drawing needed to contain only information on the general shapes and forms and was a composition of parts of many pictures and mounted specimens. When using the latter, care should be taken to understand the distortion and shrinkage which takes place during the preservation process.

The use of leaves reoccurs in many projects. Leaves for patterns were arranged to emphasize their latticelike pattern (Illus. 2-5) and

23

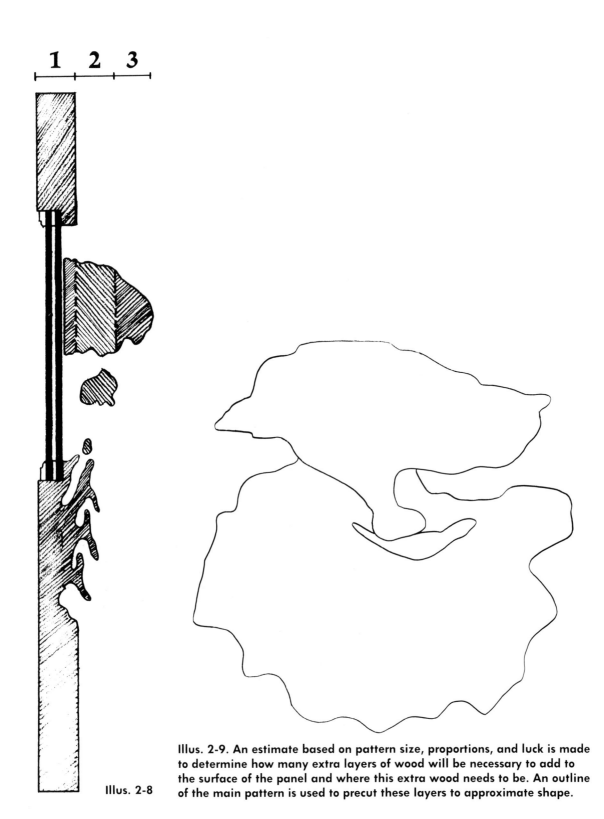

Illus. 2-8

Illus. 2-9. An estimate based on pattern size, proportions, and luck is made to determine how many extra layers of wood will be necessary to add to the surface of the panel and where this extra wood needs to be. An outline of the main pattern is used to precut these layers to approximate shape.

24

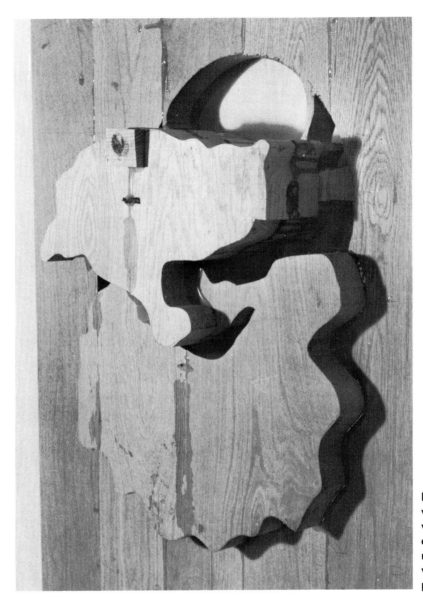

Illus. 2-10. An oblique view of the main panel with the two extra layers of wood in place and ready for carving. The window has also been partially cut out.

provide the visual weight to balance the owl. This pattern (Illus. 2-6) was drawn on a second sheet of tracing paper.

These two elements of the design, the owl and leaves, were adjusted until the proper spacing for the door panel was determined and a third sheet of tracing paper laid over the top and the entire pattern connected (Illus. 2-7). This multi-layered approach saves a great deal of redrawing and allows rearrangement of various elements of the pattern without erasing. It also insures that elements of multi-leveled carvings are not distorted when they pass under other elements of a pattern.

A shaded line drawing, not necessary for a pattern but something

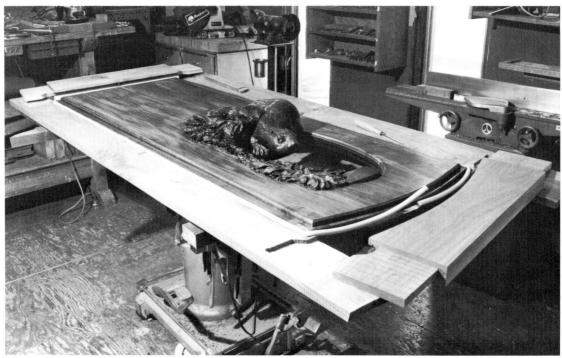

**Illus. 2-11**

useful when presenting an idea to a prospective client, gives an indication of the relief the carving will have (Illus. 2-8). The size and location of the window was determined by scribing various-sized circles on a separate sheet of tracing paper and the final juxtaposition of elements which silhouettes the owl and branches, but allows the window edge to support the small fragile branches and leaf stems, was determined and the leaf pattern adjusted to follow the curve of the window. A cross section between points A and B of Illus. 2-7 would appear similar to Illus. 2-9 and show the combination of shallow relief carving into the base panel and the high relief carving extending outward from the panel.

An estimate based on pattern size, proportions, and luck was made to determine how many extra layers of wood would be necessary to add to the surface of the panel and where this extra wood needed to be. An outline of the main pattern was used to precut these layers to approximate shape (Illus. 2-10).

Once the carving was completed, the panel had to be manufactured into a door (Illus. 2-11 & 2-12). The stiles and rails were joined with mortise-and-tenon joints using industrial epoxy. The panel was suspended by steel pins to maintain its centered position as well as to distribute its weight on the hinge side of the door. The tongue-and-groove joint between panel and frame allow expansion and contraction of the panel with seasonal changes of humidity but is sealed to eliminate air infiltration.

26

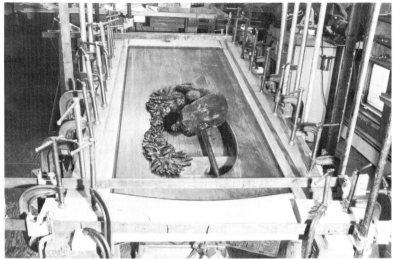

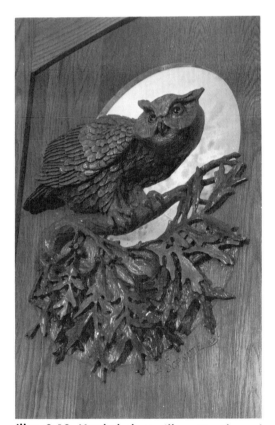

Illus. 2-13. Mottled glass silhouettes the owl and branches against a full moon when the door is viewed at night with the interior lights on.

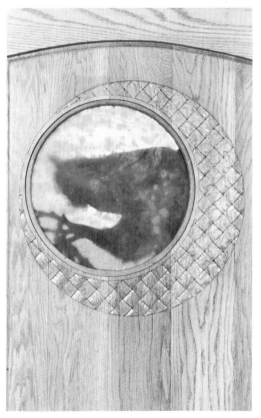

Illus. 2-14. Basket weaving carved around the window on the interior side of the door adds interest and helps center the window unit in the panel. The glass is double-layered to build color and to provide a thermal window.

# 3 *I*DEAS

Ideas are everywhere; the main problem is organization. This starts by first listing personal interests, whether they are wildlife, landscape, gardening, modes of transportation, workday or leisure activities, figures, caricatures; in short, practically anything which can be expressed visually. Even more esoteric and challenging topics are possible such as translating the power and beauty of Tchaikovsky into wood carving. Whatever these interests are, naming and defining them is a big step. An analogy would be trying to choose which of the hundreds of outdoor sports activities to participate in. Once tennis is chosen, for example, it takes only a few minutes to learn the rules and years to explore the nuances of the game.

Keep in mind the stylistic range of interpretations which are possible. A bird can be carved as a purely abstract shape and form or extreme attention can be given the re-creation of each feather. It can be static or give the impression of movement. It can be a copy of the exterior or an attempt to look inside the psyche. It may stand alone, be a part of a base, or be an integral part of an entire habitat.

Years ago I began a file of pictures and ideas which today is an indispensable reference source on a wide variety of topics. Hundreds of new and original patterns can be drawn for almost any subject matter from the thousands of pieces of information.

At first, the idea file was one folder but as the volume of information grew, it became necessary to categorize various collections of pictures into general, animal, plant, historical, ornamental style, and so on. Many of the pictures are from books and magazines but

the majority have been taken personally in zoos, museums, on business and field trips, even through the living room window at home. What is important to remember is that information from all sides of an object is necessary before it is comprehensible for carving and while carving a subject, a collage of pictures should be made up containing many photographs and small drawings, each illustrating some important detail of the subject. If necessary and available, the object or a facsimile should also be at hand.

By defining your interests and consciously collecting enough information to "memorize" the subject, the ability to look at and notice details has begun. Becoming aware of primary shapes and forms, patterns, textures, repeating patterns, symmetry, asymmetry, branching, and spiralling is just the beginning. Understanding the relationship of these details to the object and its surroundings is the next step.

## BASKET WEAVES

It is sometimes desirable for the surface of wood to present a variety of visual and textural appearances when viewed under varying lighting conditions and distances. The textures of various basket weaves carved into a wood surface can "disappear" showing only the wood grain when seen from a distance or with light perpendicular to the surface (Illus. 3-1). A closer view or more oblique lighting present an entirely different perspective. This treatment of the wood surface has been used on a wide variety of projects illustrated throughout this book.

The basket weave texture is quite easy to carve. A grid is laid out the width of an available gouge, in this case a number 5, 1 inch wide. (Illus. 3-2) The direction of cuts are drawn on first to avoid mistakes and each square in the grid is cut twice. Each square is then carved towards both stop cuts (see p. 118). Watch the grain to avoid splitting

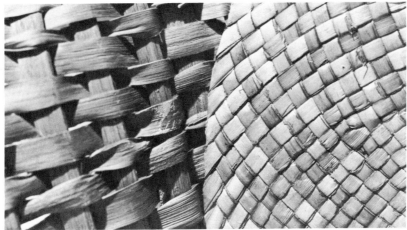

**Illus. 3-1**

(Illus. 3-3). Finally, the corners are cut out with a narrow 2mm-wide gouge (Illus. 3-4), and the edges trimmed clean with a skew chisel.

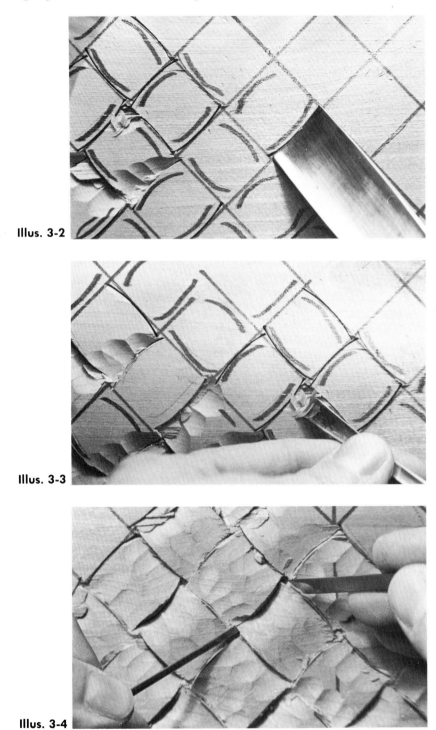

Illus. 3-2

Illus. 3-3

Illus. 3-4

# LEAVES

Most leaves are carved too flat with little or no variety. Attention should be given to the different arrangements of leaves on branches and to leaf vasculature for each species, noting that it is raised on the underside of the leaf. (Illus. 3-5 & 3-6) The spaces formed in between the leaves are just as interesting to the pattern.

Leaves blown up against a fence provide an interesting contrast between natural and geometric forms (Illus. 3-7).

In some cases the leaves are carved freestanding and they function as a physical and visual support (Illus. 3-8).

Time spent in a garden, nursery or the produce section of the grocery store and supplemented by seed catalogues will provide a remarkable variety of ideas for projects. They can be carved whole, cut in half or spread out in rows, mixed vegetables and fruit, possibly in a cornucopia with basket weave (Illus. 3-12 & 3-13).

Redwood disks are fast and easy to draw and carve and are much less detailed than carving in oak. Interesting framing can be achieved by drawing a larger pattern than needed and using a sheet of paper with the desired size circle cut out. Moving this paper over the pattern will help find the most pleasing arrangement for the carving.

Commercial work is concerned with defining an image by emphasizing surrounding elements, using traditional symbols in a unique way, coordinating interior and exterior elements or creating an entirely new concept. It is very desirable to continue this theme on signs, entryways, interior decor and printed materials such as business cards and letterheads, if possible.

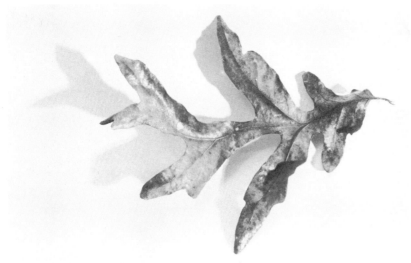

**Illus. 3-5**

31

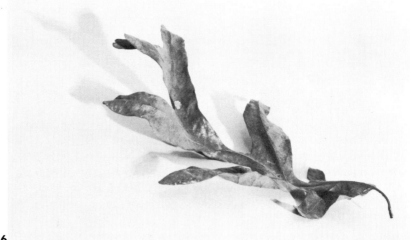

Illus. 3-6

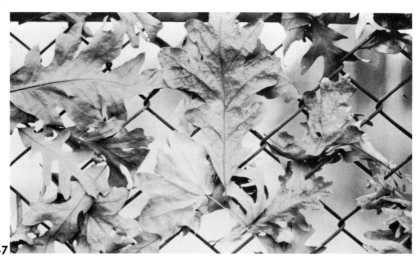

Illus. 3-7

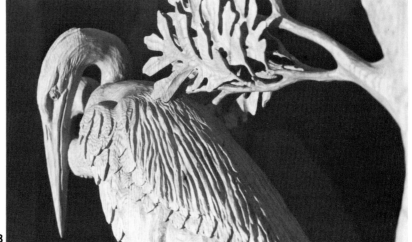

Illus. 3-8

32

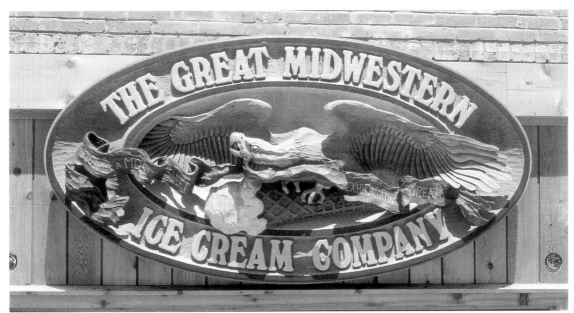

*Above*, exterior sign; redwood and house stains, 8′ × 4′ × 16″, 1980. *Right*, owl with oak leaves door; oak, double-glazed stained glass and colored stains, 3′ × 7′ × 5″, 1983.

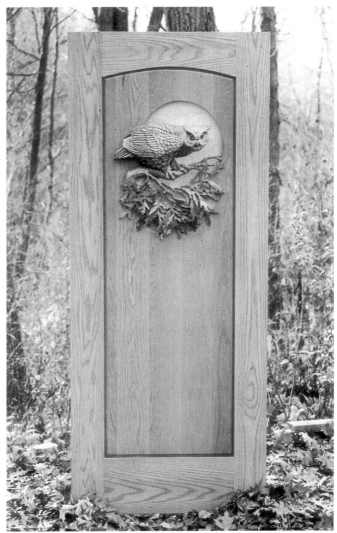

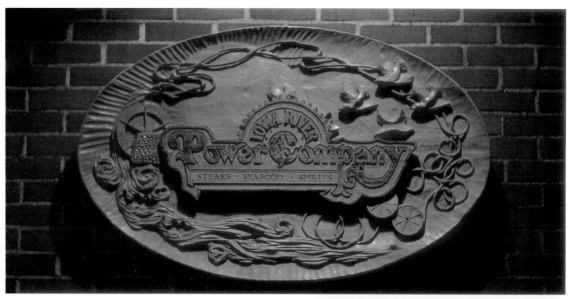

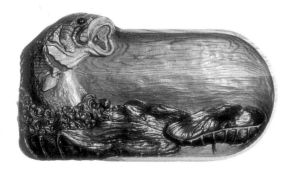

*Top*, interior sign; basswood, natural, 29″ × 45″ × 5″, 1977. *Above*, sign; oak and colored stains, 29″ × 16″ × 2″, 1983. *Right*, residential exterior door; white cedar, 90″ × 42″ × 6″, deep carving, 1981.

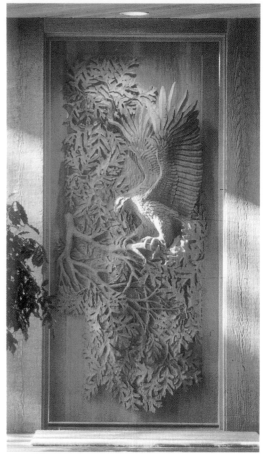

**B**

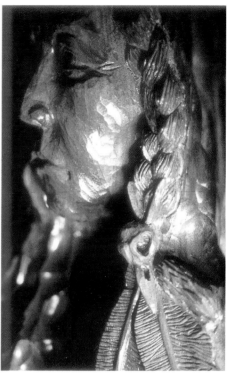

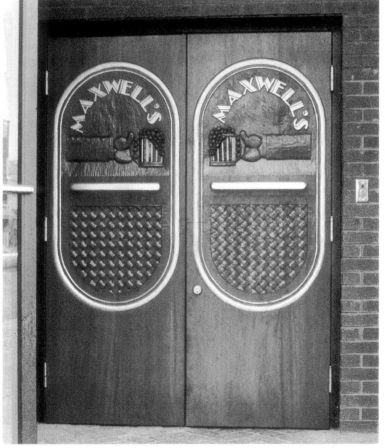

*Top left*, golf trophy; walnut and gold leaf, 24″ × 16″ × 9″, 1979. *Above*, detail of trophy. *Left*, exterior bar doors; mahogany, plate glass, brass pulls, 78″ × 32″ × 2″ each, 1976.

C

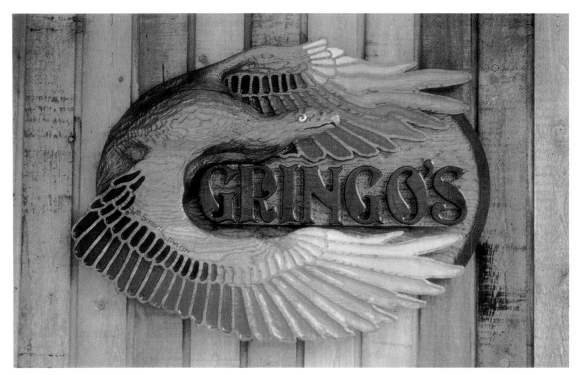

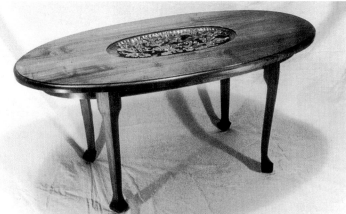

*Top,* Mexican restaurant exterior sign; oak and sign paints, 51″×3′×7″, 1981. *Left,* wall plaques; oak and colored stains, 11″×2″, 1982. *Above,* coffee table; walnut, 36″×20″×18″, 1977.

D

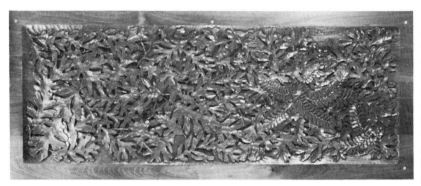

Illus. 3-9. One of a series of forest-floor tables with leaves and fern carved into the top. The surface is first carved in an undulating texture, utilizing the full thickness of the board to within ⅜″ from the back side. This prevents the finished appearance from looking "flat." Walnut, 20″ × 42″ × 1¾,″ covered with ¼″ plate glass.

# CREATURES

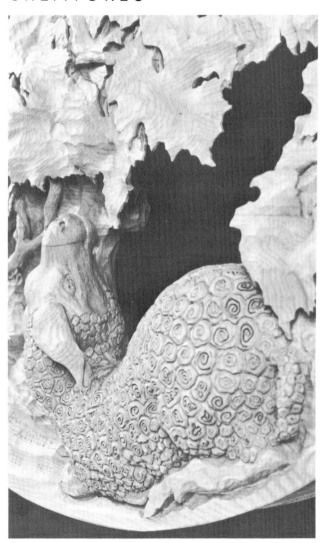

Illus. 3-10. A trip through the country with a camera was necessary to obtain information to design and complete a church commission.

33

Illus. 3-11. The wood for a pair of dragons used for exterior ornamentation was 6 layers of 2″ thick clear redwood with exterior plywood also laminated between several layers to provide extra strength to thin cross grain areas. To match the existing decor, the finish was exterior enamels.

Illus. 3-12. Carving fictional and grotesque animals can be some of the most enjoyable carving possible. There are no rules and no expert critics to ignore and no limits to the possibilities. The dragons, carved for a restaurant, were made of clear redwood laminated with plywood for strength and painted with red, green, and gold enamels.

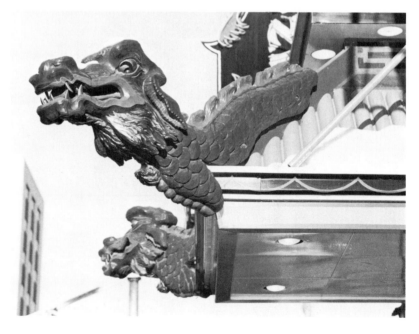

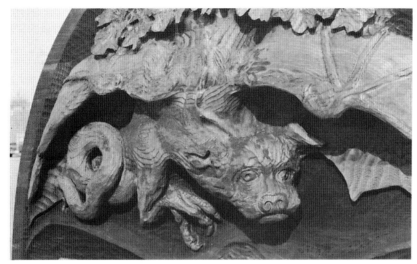

Illus. 3-13. Clear redwood was used again to carve what can only be described as part reptile, bird, bat and maybe canine. The sign is stained and finished with a clear wood finish.

# PLANTS

Illus. 3-14. Redwood disks are fast and easy to draw and carve and are much less detailed than carving in oak. Interesting framing can be achieved by drawing a larger pattern than needed and using a sheet of paper with the desired size circle cut out. Moving this paper over the pattern will help find the most pleasing arrangement for the carving.

Illus. 3-15

Illus. 3-16. Broccoli, with its wide variety of textures carved in an 11" diameter oak disk, 2" thick and lightly stained. Compromises must be made when carving this and delicate details in the coarse-grained oak but an interesting variety of textures are possible and most of the very subtle qualities of the natural plant material is defined by the texture of the wood.

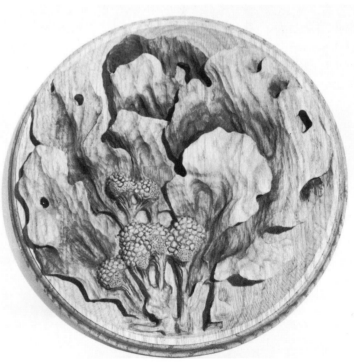

36

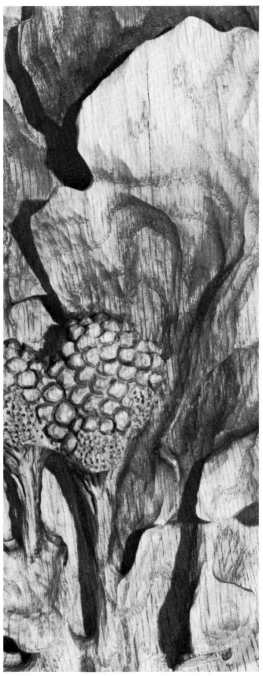

Illus. 3-17. Detail of illus. 3-16.

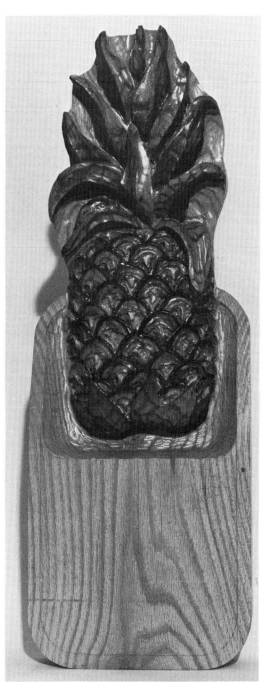

Illus. 3-18. A pineapple, a colonial symbol of welcome, was carved at the top of a 2″-thick oak house number sign, at least 24″ long or longer, depending on the number of digits.

Illus. 3-19. Flowers are common subjects, but it is very difficult to carve the delicacy and fleeting presence they evoke. Although it is rare to see flowers carved with much conviction, the chances are increased by choosing a species more suitable for portrayal in wood. The basic form of the daisy and pansy approximate a disc and work well. The marigold begins as a dome, but the many folds and thin edges lose delicacy when turned to wood.

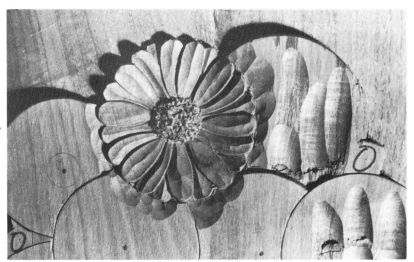

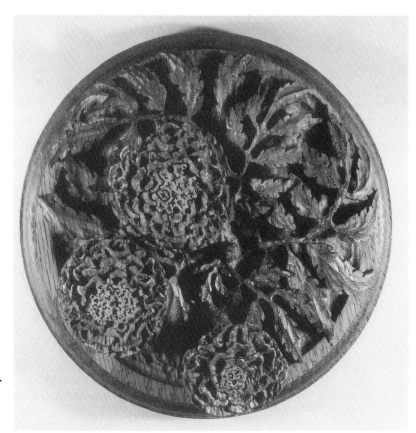

Illus. 3-20. Geraniums work because the flower head can be considered a grouping of smaller discs.

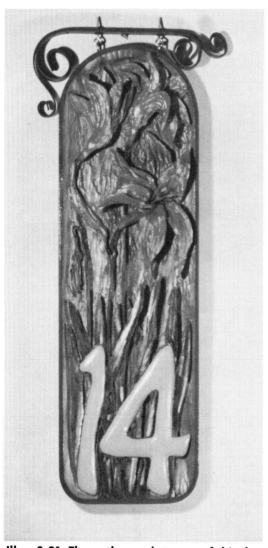

Illus. 3-21. The anther and stamen of this day lily were made from hammered copper wire.

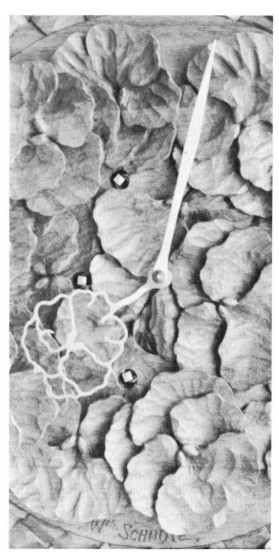

Illus. 3-22. This clock face with pansies has filed brass hands to augment theme.

Illus. 3-23. The grape-vine, both the fruit and leaves, is most enjoyable to carve. There are many varieties of leaves and other small details such as the tendrils. Note that the bunches of grapes are not actually half-round spheres side by side, but groupings which also have open areas and a stem net-work. The vines can be worked along a support or trellis.

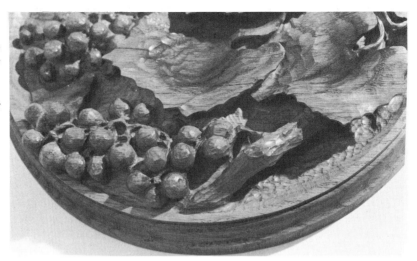

## SETTING THE SCENE

Illus. 3-24A, B & C. The theme for this front door to an Irish pub was coor-dinated with the new interior fixtures to give an indication of what to expect inside. The lep-rechauns toasting each other are high relief and the Celtic glyph is shal-low relief. The exterior sign, done previously for this pub copied the finials and the columns of the main bar and utilized a theme long favored for decorative panels behind the bar.

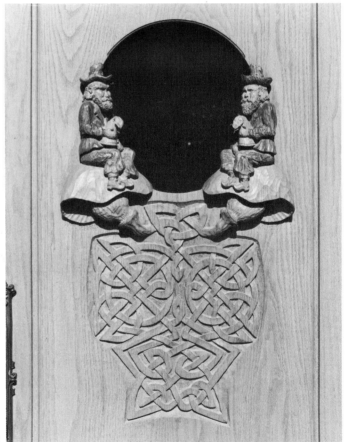

Illus. 3-24A

40

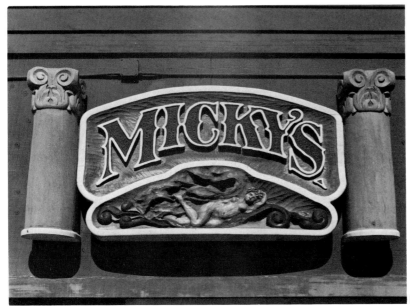

Illus. 3-24B

Illus. 3-24C

41

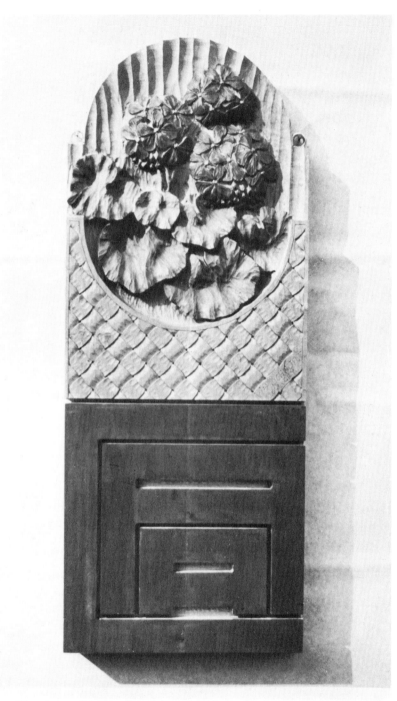

Illus. 3-25. This small maple sign, 8″ × 24″, was carved as a one-day demonstration for a group.

42

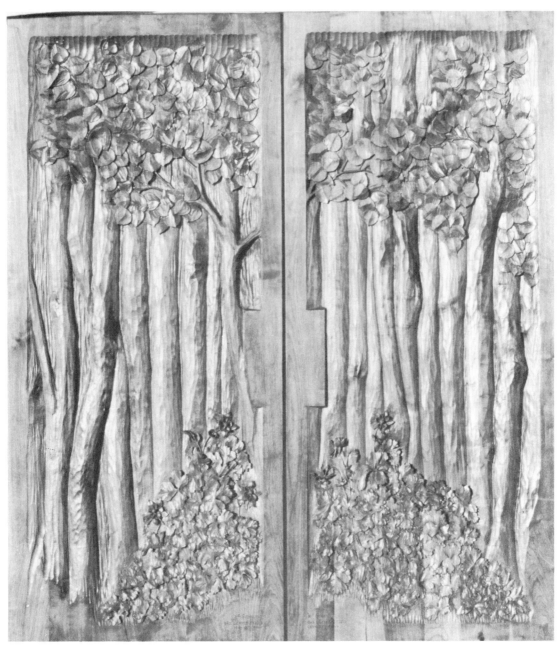

**Illus. 3-26.** The design for the doors developed after a short visit to the building site. Pictures of the columbine flower, foliage, and the aspen grove were combined to make the single panel double set of doors carved in walnut. 78″ × 36″ × 1¾″, 1975.

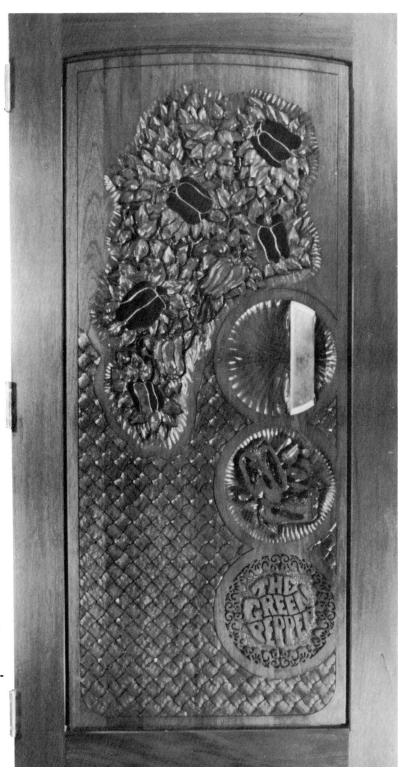

Illus. 3-27A. Pepper plants, some carved and others of stained glass, and other graphic elements decorated the mahogany doors to a pizza restaurant. The interior graphics and signs were designed and carved using similiar images and in the same style.

44

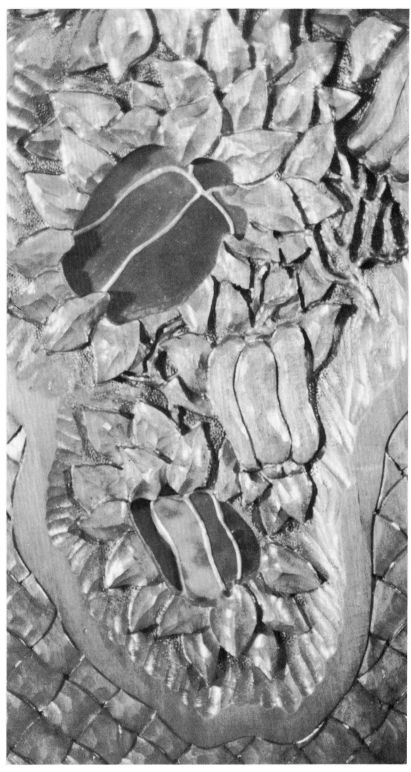

**Illus. 3-27B. Detail of Illus. 3-27A.**

45

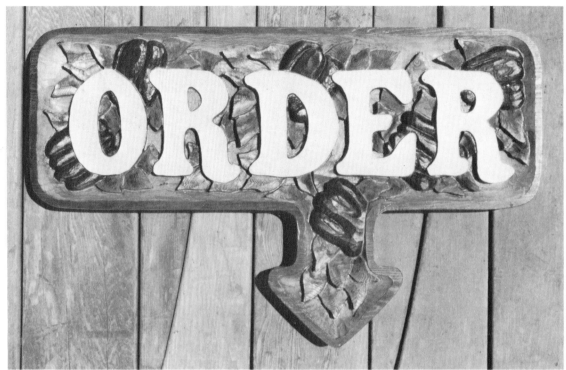

Illus. 3-28

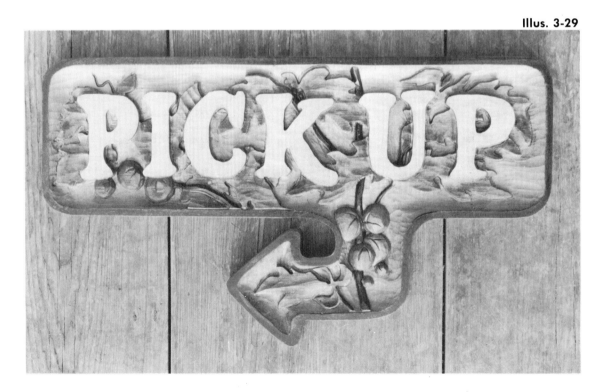

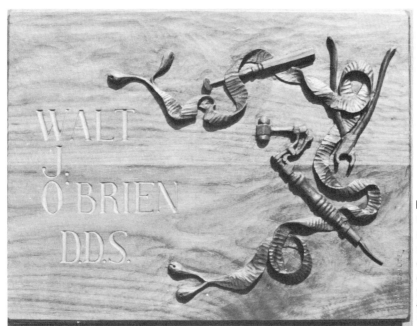

Illus. 3-30. Antique dental tools borrowed from a dental school were used as models and carved intertwined with a ribbon in walnut with 23 K gold leaf lettering for this sign. 14″ × 17″, 1974.

Illus. 3-31. Computer chip, part of a sign for an electronics retailer.

# 4 *I*DEAS INTO WOOD

While most people can intuitively decide how much of a piece of wood should be carved and how much left as a border (usually about ⅔ carved), there is a mathematical progression of numbers which gives basic information on perspective, helps avoid common mistakes and provides examples that will increase the likelihood of producing acceptable relief carvings.

The natural world provides one of the most interesting and relevant ratios known. In 1202 AD, Leonardo Fibonacci described and analyzed a series of numbers created when the last two numbers in a sequence are added together to yield the next: $1 + 2 = 3$, $2 + 3 = 5$, $3 + 5 = 8$, and on to $\infty$. It was noticed that all numbers after the fourteenth in the series could be divided by its preceding number always giving the same .618034, also called the golden mean. This ratio provides an excellent starting point when determining the length and width of a panel or determining a ratio of carved area and uncarved surface for any panel. This ratio has determined the dimensions of the Parthenon and the basic telephone as well as thousands of other items. If the shorter dimension divided by the longer dimension equals 0.618034, it will then also be true that the sum of the long and short dimension divided by the long dimension will equal 0.618034. If the ratio of the sides of a rectangle equal .618, the result is called a golden rectangle. When a golden rectangle is divided into a square, the remaining rectangle also has the same relationship between its long and short dimension or .618. If each

golden rectangle is further divided into a square and the next smaller golden rectangle and the centers of each resultant square joined with a curved line, the golden spiral, so prevalent in nature is formed (Illus. 4-1). The best-known example is the spiral shell (Illus. 4-2), but the long arms of our galaxy spin out into space in the same ratio.

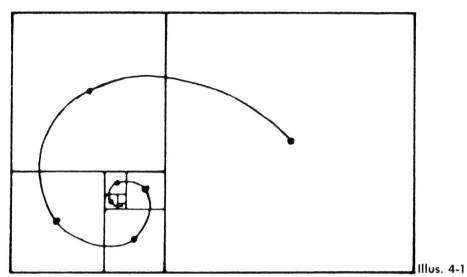

**Illus. 4-1**

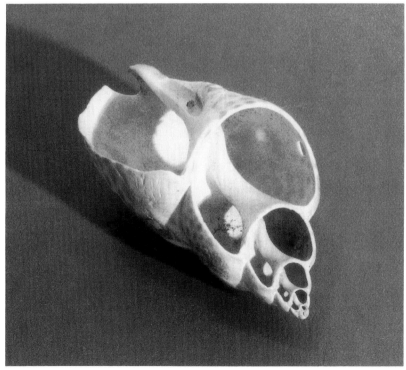

**Illus. 4-2**

# PERSPECTIVE

An acquaintance with the fundamentals of perspective is useful for relief carving and pattern layout. It can resolve problems which make some carvings seem unnatural or stilted and aid in proper proportioning. Patterns can be carefully drawn to scale and all sides corrected to set vanishing points, or drawn intuitively if one is practiced.

A very common example of a vanishing point is the sides of a straight highway extending ahead of a car. These lines will converge on a single joint, which if the road is long enough, will also be at the same level as the horizon.

Foreshortening, the enlarged appearance of very close objects, can be compensated for when carving large or tall statuary. If carved anatomically correct with a vanishing point up in the sky, a large figure carving may appear to have narrow shoulders and a "pinhead."

Very low relief, typified by coins and medals, is thin and usually presents a view of one surface of an object. In portraiture, this view is usually a side view but as the relief becomes greater, as in wood carving, more surface is created and therefore additional information must be carved around the sides, and if relief is carried to the extreme, carving in the round may become necessary.

**Illus. 4-3 & 4.** The basic shape of this steam engine and tender is two rectangular blocks and because it has been photographed perpendicular to and centered on the side, all lines on the front side of this train which are parallel to the ground will remain essentially parallel if extended to the right or left. Because the camera was slightly above the cars, the lines parallel to the ground which define the ends of each block will be seen converging towards a point, often off the pattern, called the vanishing point.

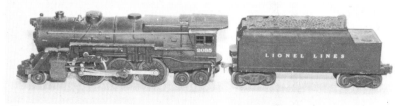

Illus. 4-3

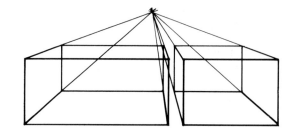

Illus. 4-4

Illus. 4-5

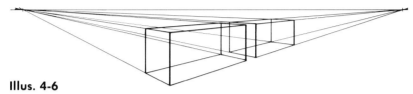

Illus. 4-6

Illus. 4-5 & 6. Two-point perspective is necessary when two sides of an object are visible such as this oblique view of the train. These cars are basically block shaped and if the lines which are parallel with the ground are extended for each side showing, they will converge, usually off the pattern, at their respective vanishing points. A line drawn between these two points will represent the horizon for this scene and it also represents the viewer or camera's eye level.

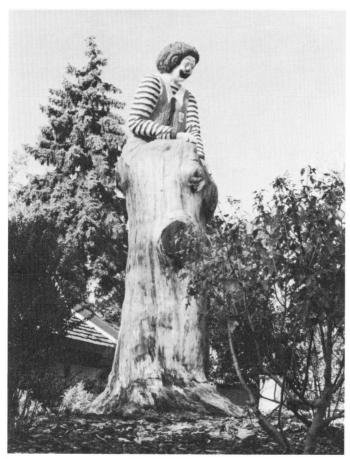

Illus. 4-7. This statue was carved from the trunk of a Douglas fir which had been struck by lightning. The head is approximately 19 feet above grade and it was necessary to keep a constant check on the proportions from the ground while it was being roughed out. The head was completely carved first and the body scaled to fit.

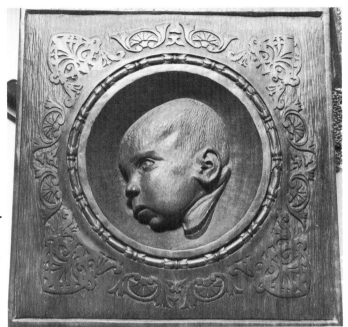

Illus. 4-8. A first daughter and the first carving of a face provided a difficult lesson in perspective. The face originally was to be more oblique but problems rapidly developed attempting to resolve the natural perspective of the side view with the distortions necessary to provide detail on the frontal surface of this face.

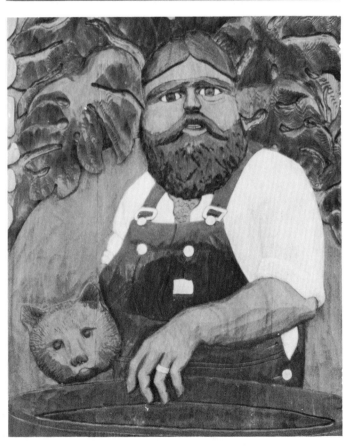

Illus. 4-9. This redwood sign manages to display two examples of "glass door" perspective, so called because the faces of both the animal and the human appear to have had a glass door slammed shut as they were entering. The sign is effective a short distance away, but is less believable up close. An oblique view or added wood for high relief would have been a better choice.

# GRAIN AND COLOR OF WOOD

For the most part wood carving is a subtractive process whereby the loss of material in the wrong location usually dooms the entire project. There is an intimate relationship between the artist, the material, and the tools necessary to produce results. The wood is one of the first considerations when planning a carving project, and the wood carving corollary to the adage "form follows function" is "form follows grain." As near as possible, the long grain of the wood should align itself with the long axis of the flow of the pattern, both for visual impact and for strength and stability. The eye has a tendency to follow the patterns of grain. This can be used to augment the intent of the carving and the choice of species of wood used can further enhance this tendency.

Various wood colors give the carver an amazingly varied palette from which to choose. It is important to remember that dark woods require careful control of lighting, especially the intensity, to produce the shadow line necessary to discern detail.

# LIGHTING

Carving is basically the manipulation of shadows to obtain the desired effect. Without properly oriented light, little, if anything, is visible of relief carving. In fact, the manipulation of light and shadow is so important, the success or failure of the project is at stake. Ideally, the architectural design stage is the best time to consider lighting—either ceiling or side-mounted spots and flood lights, or special effect lighting such as fluorescent or neon. Some carving will need some or all of these arrangements and pierced work, with or without glass, may need backlighting. Ceiling-mounted lighting very close to the wall can "wash" a textured

**Illus. 4-10A**

**Illus. 4-10B**

**Illus. 4-10 A & B.** The importance of proper lighting is easily demonstrated with two photographs of the same carving. Light perpendicular to the surface has washed out all detail. When the light is moved to a steeper angle with the surface it allows shadows to highlight and define details.

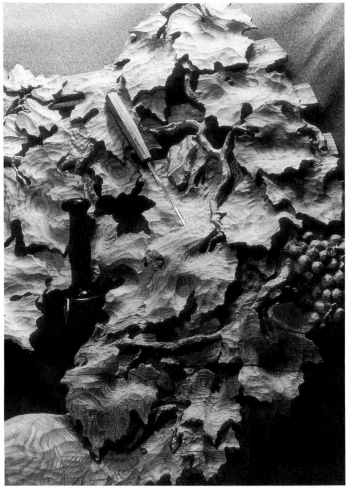

Illus. 4-11. Because overhead lighting was available, the grape leaves shown in this detail were carved to overlap in such a manner that the top surface of each leaf would be highlighted by the shadow produced. Because the panel was mounted high on the wall and seen from some distance, the carving was almost 6″ deep, producing very strong highlights and shadows.

Illus. 4-12. An early carving, these white oak leaves were carved with a very limited set of gouges and little appreciation for shadows. The very busy texture of both the top surfaces and background provide no variation in contrast and obliterate the design.

54

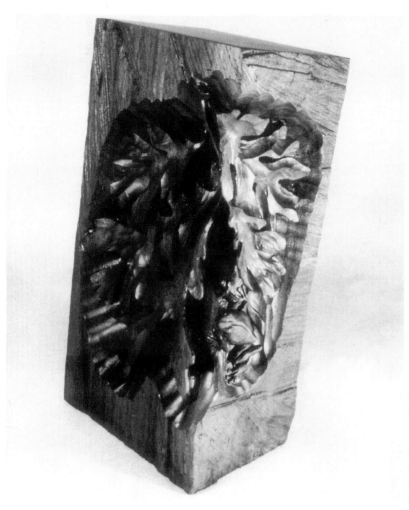

Illus. 4-13. Carved eleven years later advantage was taken of a wide variety of gouges allowing the design to dominate the pattern. Because proper lighting was available during the carving, progress towards the desired effect could be monitored continuously.

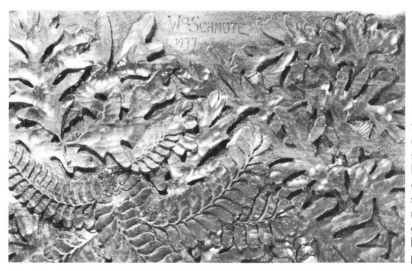

Illus. 4-14. To give contrast between the foreground and background small indentations are hammered into the background, a process called stippling. In this case nails were soldered together and rotated while hammering to vary the pattern of holes.

surface such as brick with light and, in effect, become the background of a deep relief carving.

It is almost always desirable for carved panels to be mounted away from the wall. There are two reasons for this: first, to allow the front and back of the panel to acclimate equally to the ambient temperature and humidity; second, to provide a shadow line around the panel, visually separating it from the wall and giving it an appearance of greater relief.

During the carving process, the studio lighting should be adjusted to simulate the lighting conditions the final piece will be displayed in. The studio lighting will then determine the order, depth, and texture of cuts to be made.

One characteristic of wood which can sometimes be manipulated to obtain contrast is the variations in the reflection of light at different angles to the longitudinal grain. The wood will appear much lighter on the flat surface of a board and darker when more end-grain is present. This effect is increased when any type of finish is applied and often it is possible to highlight areas of a carving simply by changing the angles of each cut, thereby exposing a greater or lesser percentage of face- and end-grain.

# RIBBONS

Ribbons and banners have long been a favorite sculptors' subject. Their only function may be to fill out a design or just be fun to draw and carve. Lettering or a motto can effectively be added to a design without seemingly appearing out of place. At times, a ribbon can physically tie together diverse elements of a design and become a feature in itself.

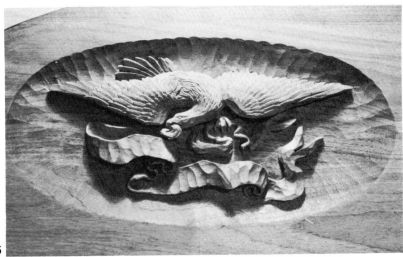

**Illus. 4-15**

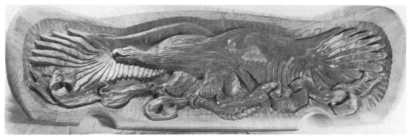

Illus. 4-16

When roughing out the carving of a ribbon, the many folds and turns can become confusing unless some reference can be maintained. Establishing the edges works and depending on the scale of the carving, this edge can be ¹⁄₁₆ to ½″ thick. By keeping the top surface approximately 90° to this edge and both edges as parallel as possible, the ribbon should appear natural. There is great leeway for variances though, because the ribbon should not be carved stiff and flat, but should appear more pliable, twist in some sections, and become round and narrow as in Illus. 4-15, where it passes through the eagle's beak.

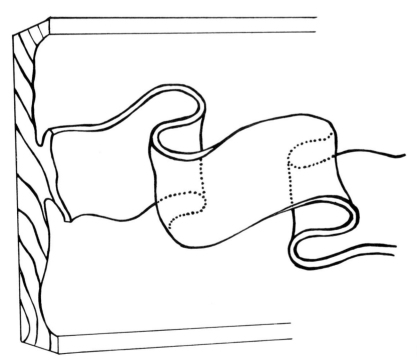

Illus. 4-17

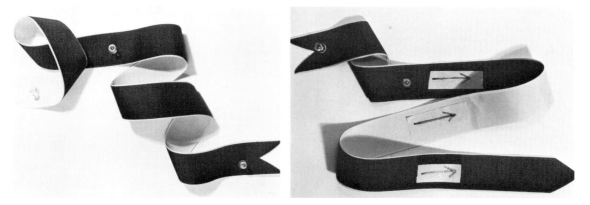

Illus. 4-18. A length of two-toned ribbon can be pinned in any desired configuration and used as a reference for pattern-making or direct carving.

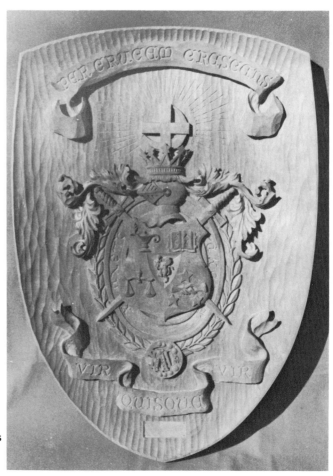

Illus. 4-19. Honduras mahogany, 1977, 24″ × 36″ × 2″.

# BORDERS

Repeating borders, typified by the laurel leaf (Illus. 4-21) can surround and unify a design or divide and separate various elements of relief carving. It can also form the basis for the overall texture of a carving as it did for the Aztec calendar stone (Illus. 4-35). As the prototype for an injection-moulded clock, it approached the limits of endurance for repetitive carving. It forms a pleasing overall texture and there are slight but significant variations, but the center must be a self-portrait of the original artist shortly after he finished this piece.

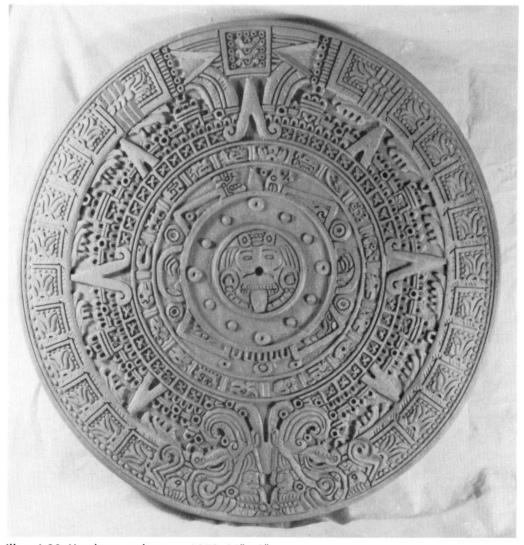

**Illus. 4-20. Honduras mahogany, 1973, 24″ × 2″.**

Illus. 4-21. Redwood, 1982, 24″ × 30″ × 1.5 & 3″.

Illus. 4-22. Wood, especially fine hardwood, has an intrinsic aesthetic value all its own and its presentation is as important as the carving is. A pleasing ratio of carved to uncarved areas is desirable. The heavily textured surface of this table top is visually balanced with the smooth surface. The carving was continued into the uncarved area by an incised line. Walnut, 1974, 22″ × 53″ × 2″.

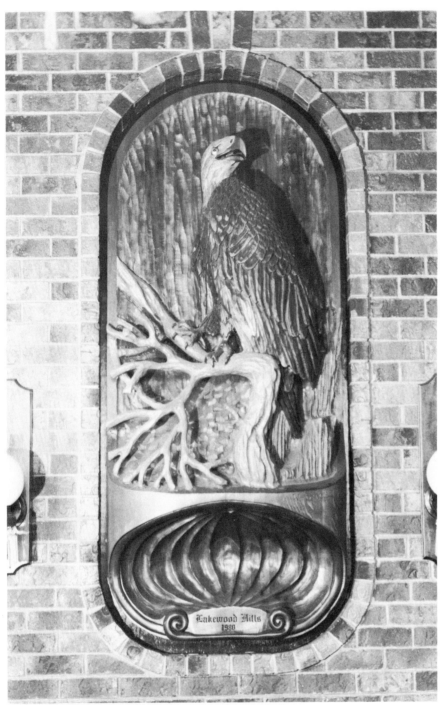

Illus. 4-23. A large carving of a bald eagle was carved with an integral visual base to provide a transition from architectural detail carving to the naturalistic wildlife carving. Redwood, 1980, 3′ × 7′ × 15″.

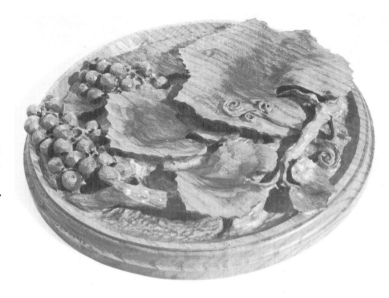

Illus. 4-24. Various outlines, anything to get away from the basic square or rectangle, can be most effective in giving individual qualities to carvings. This vegetable carving was drawn within a circular outline but carved to allow the pattern to spill over the borders. Oak, 1981, 11″ × 2″.

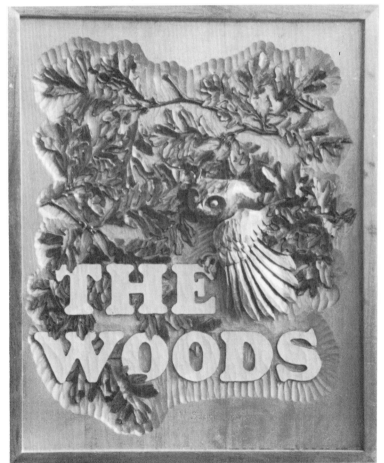

Illus. 4-25. Framing, borders, and outlines will improve and provide a more finished look to relief carvings in the same way proper matting and framing is important to paintings. Relief carving, particularly high relief, can be more difficult to center properly on the panel because extra-thick areas of wood represent greater visual weight than a flat surface. Redwood, 1974, 36″ × 48″ × 1.5 and 4.5″.

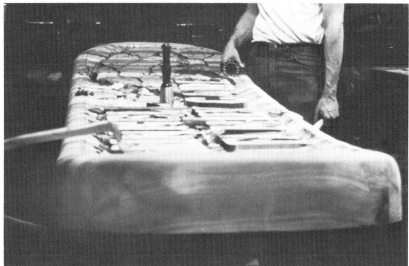

Illus. 4-26 A & B. A large sign has a rounded border. The entire panel was glued-up as part of an arc to reflect the quality of encircling care.

Illus. 4-26A

Illus. 4-26B

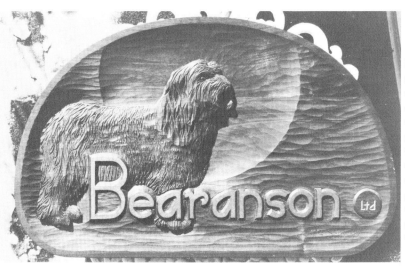

Illus. 4-27. The graphic circle in this carving and an increase in the depth of the background provides additional thickness of wood for the features of the head without substantially weakening the entire sign. It also focuses attention on the features of this breed of dog. Walnut, 1981, 15″ × 24″ × 1″.

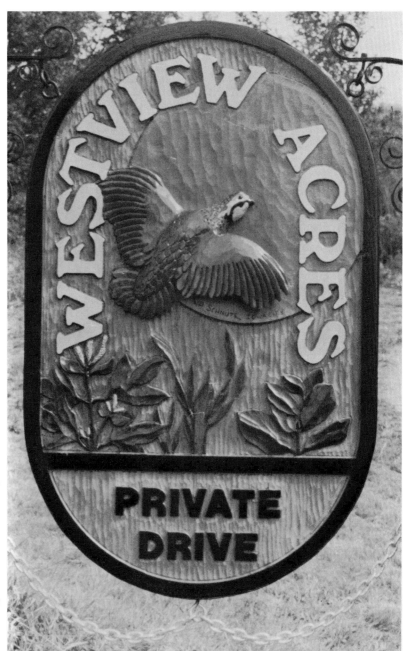

Illus. 4-28. The quail and plants seen at the location for this sign suggested the theme and the name of the housing development made it obvious that a large orange-stained circle was needed to fill out the design. The oval in this carving and an increase in the depth of the background provide additional thickness of wood for the features of the head without substantially weakening the entire sign. Redwood, 1973, 32″ × 48″ × 1.5 and 3″.

## REPEATING PATTERNS

Objects carved in multiples can present a graphic repeating effect and provide a pleasing overall texture. It sometimes can provide an element of surprise when the texture is recognized as a series of objects.

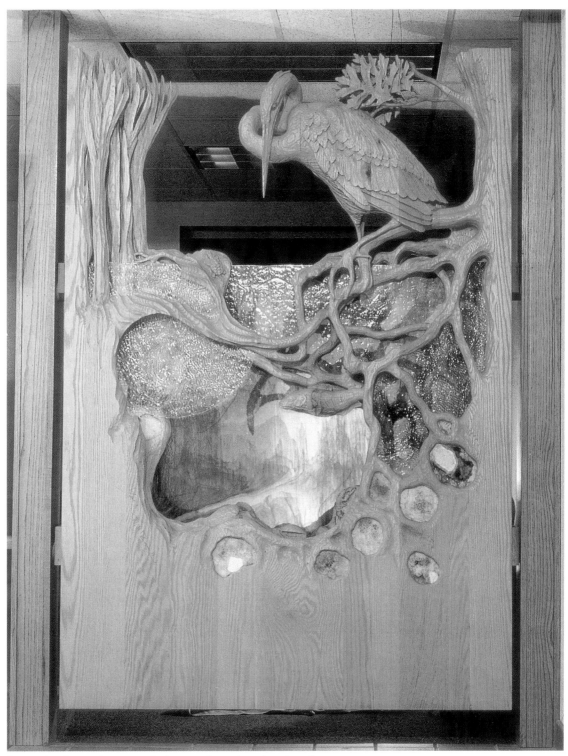

Room divider; oak, stained glass and geode, 5′ × 7′ × 7″, 1983.

A

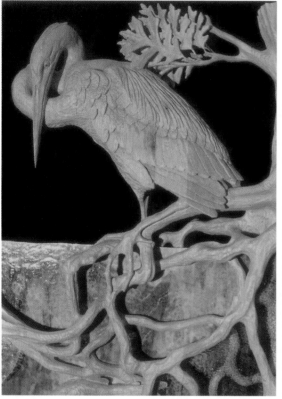

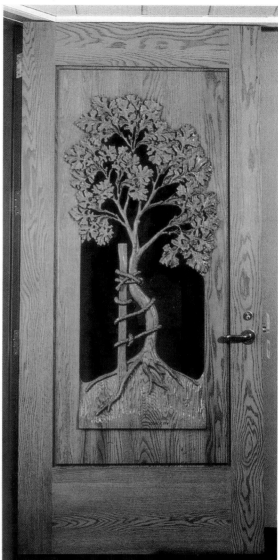

*Top left*, detail of divider on opposite page, glass and turtle. *Above*, detail of leaves, blue heron roots and glass. *Right*, detail of geode, glass and crawfish. *Top right*, orthopedic logo designed for an interior door; oak and bronze safety glass, carved both sides, 44″ × 90″ × 3½″, 1983.

B

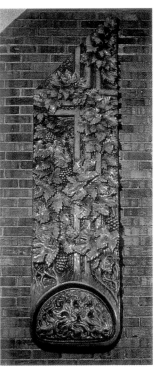

*Left,* church panels of grape and wheat, linden wood, 36″ × 90″ × 6″, 1979. *Below,* 125 th Anniversary Commemorative Medallion; pierced oak, 4′ × 5′ × 6″, 1983.

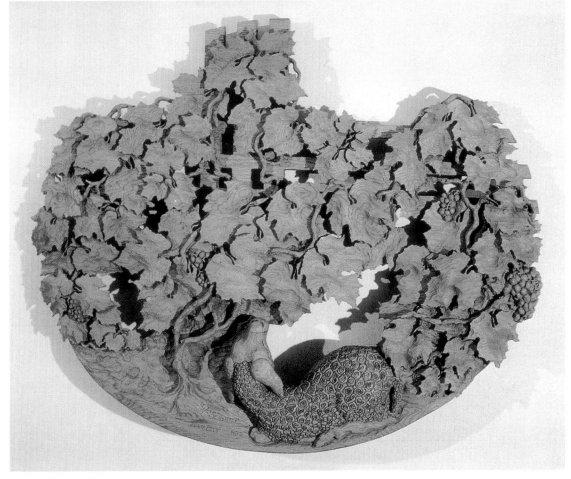

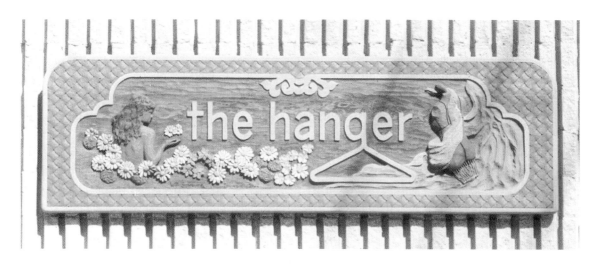

*Top*, exterior dress shop sign; redwood and house stains, 8′ × 30″ × 2″, 1975. *Above*, exterior sign; oak, colored stains and paint, 25″ × 26″ × 6″, 1981.

D

The symbol for the benzene ring, the beginning structure for thousands of organic chemicals and drugs, was used to form a repeating chain pattern for the walnut plaque (Illus. 4-29).

Mirror-image, a form of repeating pattern, is a common and easy method to enlarge or extend a pattern and its applicability is endless. By using tracing paper and ink, both sides of a pattern can be drawn at the same time. The back side can be reproduced by a copy machine to give the full pattern (Illus. 4-30A, B, & C). Sometimes it is necessary to overlap part of the design for continuity. Many types of panels can be produced quickly in this way. It is also possible to combine patterns in any other multiple.

I have used a version of the kaleidoscope which has mirrors and a lens which allows any scene or object to be viewed as four symmetrical images. Lenses which form multiple images in various juxtapositions are available as screw-on accessories for cameras and the transparency produced with them is easily adapted to a pattern.

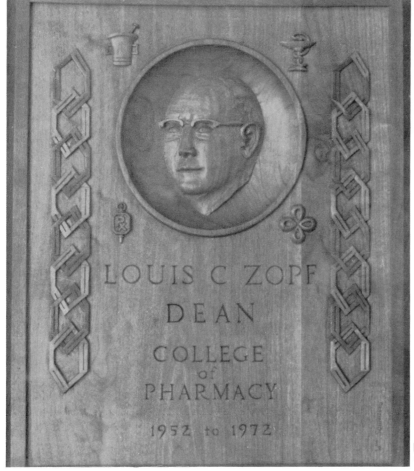

LOUIS C ZOPF
DEAN
COLLEGE
of
PHARMACY
1952 to 1972

Illus. 4-29. Walnut, 1972, 24″ × 36″ × 2″.

65

The restaurant logo of a man sitting against a cactus (Illus. 4-31) made it a difficult shape to deal with when designing this double set of doors. The pattern could be enhanced by using its mirror image which also allowed the scarf to become the door pulls by adding an extra thickness of wood to the hat brim and scarf area. The door was still uninteresting and no logical stopping line existed for the glass between the arms of the cactus until a large circle was drawn, which visually connected the two doors. This circle was widened again by a border of very coarse gouge cuts.

**Illus. 4-30A**

**Illus. 4-30B**

**Illus. 4-30C**

**Illus. 4-30A, B & C. Repeating patterns of cattails, trees, and corn stalks in the scenes on this mantel are a repeating pattern along its length. Honduras mahogany, 1981, 6″ × 6″ × 72″.**

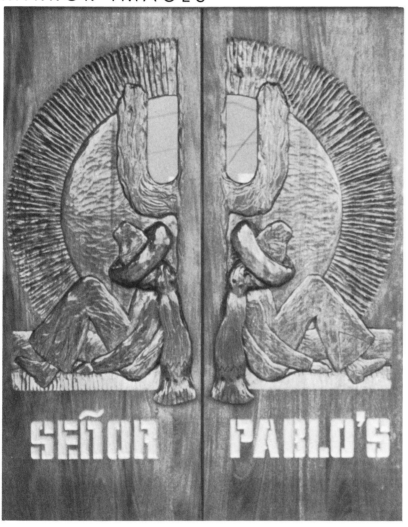

Illus. 4-31. The logo for this restaurant made it a difficult shape to deal with when designing this double set of doors. The pattern could be enhanced by using a mirror image of itself, which also allowed the scarf to become the door pulls. An extra thickness of wood was added to the hat brim and scarf area. The door was still uninteresting and no logical stopping line existed for the glass between the arms of the cactus until a large circle was drawn, a third element, which visually connected the two doors. This circle was widened again by a border of very coarse gouge cuts. Honduras mahogany, 1982, $36'' \times 84'' \times 2 \times 4''$.

Illus. 4-32 A & B. Mirror image, a form of repeating pattern, is a common and easy method to enlarge or extend a pattern. Its applicability is endless. By using tracing paper and ink, both sides of a pattern can be drawn at the same time (Illus. 4-32A). The back side can be reproduced by a copy machine to achieve the full pattern. Sometimes it is necessary to overlap part of the design for continuity and many types of panels can be quickly produced. It is also possible to combine patterns in any other multiple as well. I have used a version of the kaleidoscope which has mirrors and a lens which allows any scene or object to be viewed as four symmetrical images. Camera lenses are available that form multiple images in various juxtapositions and the transparency produced is easily adapted to a pattern.

Illus. 4-32A

Illus. 4-32B

Illus. 4-33. These replacements for missing pieces to a book case represent the use of mirror images on furniture.

# 5 $P$ATTERNS

Patterns, or the lack of them, can be the single most limiting element to the creation of quality wood carvings. All the skill and technical ability acquired over a long period of time is wasted if the finished project has little or no artistic merit and a fine, flawlessly textured relief carving has little value if it is ungainly and awkwardly designed. A well-thought-out and designed pattern can be carved with very modest carving ability and be an acceptable and pleasing work of art.

It is ironic that the more proficient one becomes at wood carving, the less need there is for patterns. With time and practice, it is possible to visualize a project in the mind, to walk around it and change the composition at will. The many hours of studio-time spent drawing patterns is almost exclusively for the customer's benefit, an attempt to draw in two dimension what the three–dimensional carving will look like (Illus. 5-1). Once the approximate shape and size has been determined, all the drawing is done on the wood with pencil and knives as the work progresses. In this way, it is possible to let the wood, its texture and grain direct and control some of the design process and it allows spontaneity in the creative process.

There are several easy systems for the production of line drawings to be used as patterns. First, material collected from the idea file, (see p. 28), fishing trip, market, etc., is examined and a decision made as to how best carve and display the subject. The bass (Illus. 5-2) was drawn jumping through the water surface with lily pads, because good pictures of these plants, taken on a nearby lake, were found in the file while looking up pictures of fish. The outline of part

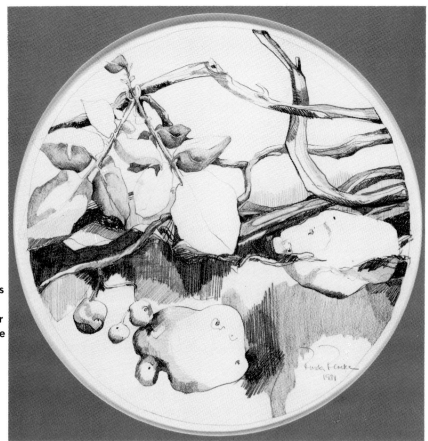

Illus. 5-1. One of a series of drawings by Ronda Reinke Schnute, used for the pattern for vegetable carvings, is done with clean, precise lines with detail and shading enough to clearly visualize these potatoes as three dimensional objects.

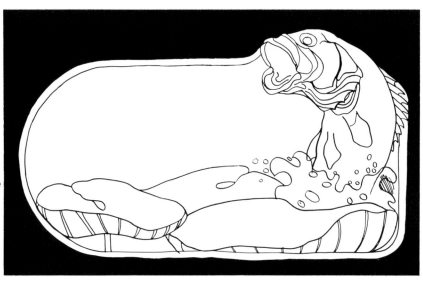

Illus. 5-2. This pattern incorporates the fish as part of a sign outline and is intended for carving out of 1¾" oak. The length of the sign can be adjusted to accommodate longer names or business identification. The lettering can either be raised or incised into the background.

of a design is often used to form the border for relief carving to avoid the monotony of the basic rectangle. An easy variation would be an underwater perspective, with this fish coming from between the weeds with the pads and their textured veining at the top of the carving.

A pattern can be drawn freehand but photographs could be used for enlargement with the currently available photocopying machines which can both enlarge and reduce the size of the original image. For larger patterns, an opaque projector (Illus. 5-3 to 5-5) can be used allowing a much greater degree of enlargement. These machines differ from overhead projectors because they allow the use of material found in books and magazines, photographs, and even small objects to be traced for patterns. Models range in price from cheap to expensive. They are used in a darkened room and several high wattage bulbs will produce a brighter image, but a cooling fan is needed. The lower-priced units have uncorrected and uncoated lenses so the focus will be sharp in the middle of the image but will have poor peripheral focus and the uncorrected lenses will have severe color aberrations of red-green-blue which at extreme enlargements can make a black and white edge ½ to 1 inch wide. Then there is some adjustment of the pattern to be done, especially for straight, parallel lines as in lettering.

Even with a small enlargement capacity of 6 × 6 inches, it is possible to carefully match and enlarge adjacent areas of large material to make a composite enlargement, but it is easier to take an instant picture of the material so that a pattern too large to be projected at one time can be condensed to a print which can be. A color or black and white print can also be used, but a slide and projector can provide the brightest, distortion-free image for enlargement for patterns and is the method of choice.

Patterns for carvings do not necessarily need all the detail drawn in, they actually only need lines which represent stop cuts such as the outer edge of an object, or as in the bass pattern (Illus. 5-2), the edge of the gills or fins. The general location for the eyes and other details is indicated, but because a pattern is a two-dimensional view of a three-dimensional relief carving, the locations of these details shift as the curvature of the relief is established. This mental transition from total dependence on the pattern, to a memorization of the details and characteristics of an object collected from as many points of view as possible, is what makes high and deep relief possible. When carving in the round, it is usually possible to start with a front- or top-view pattern and a side-view pattern, saw both sides with a band saw, and begin to round the edges. This approach is generally not possible with relief carving.

For visual relief and greater variety, simply starting with a sheet of paper any shape but square or rectangular will force a change in the way a pattern is drawn or laid out. Often the required shape of the project, such as a chair back, will control the flow of a pattern. In

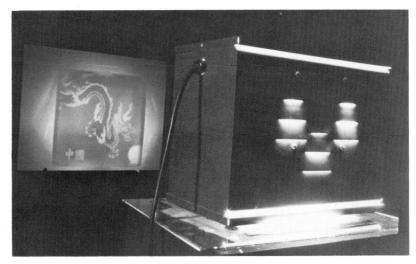

**Illus. 5-3. If a drawing or photograph represents the desired position of the subject matter it can be enlarged directly producing a working pattern for carving, by using an opaque projector. A drawing was used to make the pattern to carve a dragon from walnut in 1969.**

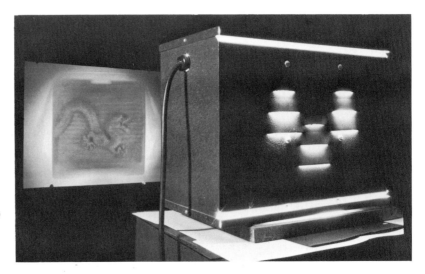

**Illus. 5-4. It is possible to produce a pattern by positioning the projector over a wood surface.**

order to prevent a design from wandering, so to speak, an imaginary border can be used to give limits to various elements, but the use of this device should not be apparent in the finished carving.

Some office copy machines are able to enlarge or reduce patterns to any size. A slide of a larger object can be projected to any size and traced.

Transferring a pattern to wood can be easy if it is one layer of wood, but can be difficult in deep and high relief carvings.

The pattern is used as a cutting guide. The width of each board is lined onto the pattern so it can be cut to exact length before glue-up and the wood for any additional layers can also be cut to length.

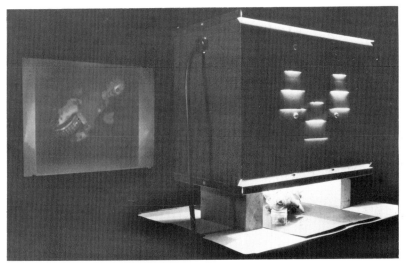

Illus. 5-5. It is also possible, within reason, to block up the projector and obtain a pattern from larger objects, in this case, a small wind-up toy.

I am always hesitant to use patterns and logos designed by graphic artists and others who design exclusively in two-dimension. Many requests for large signs start with a 5 × 7″ drawing of a logo and it is expected that it can be enlarged 50 to 100 times and still look the same. Unfortunately, small areas of minute detail enlarge into areas of indecipherable scribble or solid mass and small empty areas become vast wastelands of nothing. Clever graphic techniques can become absolutely classic confrontations between two-dimensional art and three-dimensional carvings.

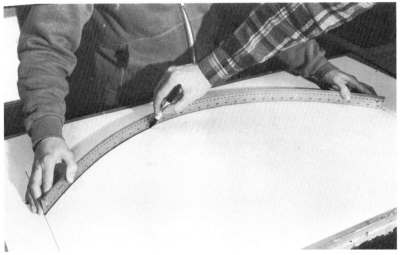

Illus. 5-6. A concentrated effort should be made to avoid square corners and to vary the outlines of carved panels. The flexible steel ruler is most useful for this purpose. It is possible to define the entire outline, one half or one fourth of an ellipse with this ruler.

Illus. 5-7. Occasionally, the shape of the project can direct the general character of the drawing such as this pattern for a chair back. This long narrow space produced a very streamlined eagle, a much more satisfactory pattern than trying to force a predrawn pattern to fit.

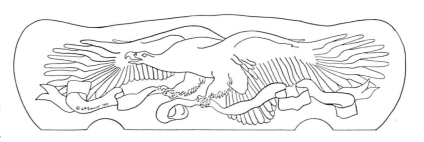

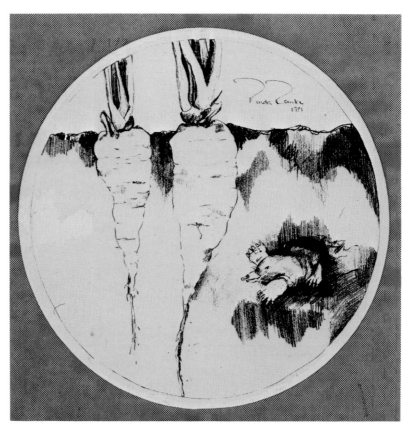

Illus. 5-8A

Illus. 5-8 A & B. Drawing within a circle has influenced the composition and layout of this pattern of a "mole's-eye view" of a carrot patch and also became the outline for the final carving.

74

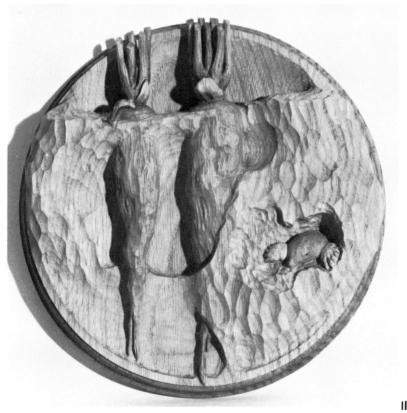

**Illus. 5-8B**

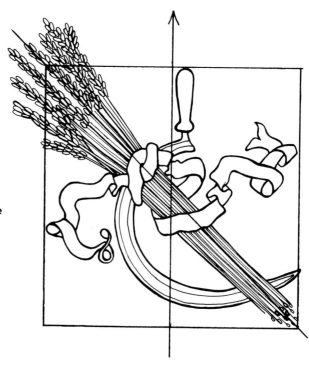

Illus. 5-9. The initial sketch for a door panel was drawn within the confines of a square, except for a small area needed to give visual weight to balance the rest of the motif. The square border, however, is not part of the design, it is only a drawing aid. The final design was rotated slightly because it is unlikely that the sickle handle would come to rest straight up and the design does not appear to "hang" from its natural center.

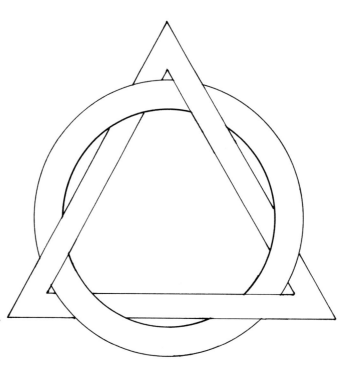

Illus. 5-10. This two-dimensional triangle and circle graphic looks deceptively simple on paper, but to effectively carve it in three-dimensional relief requires the triangle to be carved straight and flat below the board surface while the circle is carved undulating over and under the sides of the triangle.

# PATTERN TRANSFER

The fastest and simplest method to transfer a pattern to the wood surface is to apply rubber cement or spray adhesive to the wood and paper surface, let it dry, and lay on the pattern (Illus. 5-11). If the pattern will have to be moved, adhesive is applied only to the wood surface, but it will not stay in place for routing. The paper is carved away and any remaining paper will pull off and the remaining adhesive will roll off the wood leaving a clean surface which will not inhibit subsequent finishing. For large patterns it is necessary to spread newspaper over the wood surface, lay on the pattern and stick one edge down and then pull the newspaper out while pressing the pattern in place. Like any contact cement, it is a one-shot process and once the two dried glue surfaces come together, it is very difficult to reposition.

Carbon paper can be used (Illus. 5-12). Tape the pattern over it and trace the outline onto the wood. This paper comes in different colors so a dark line will show on light woods and a white line on dark woods.

For very large projects or irregular surfaces where spreading glue is difficult and tracing difficult, the star-shaped tracing wheel is useful (Illus. 5-13). The pattern can be traced on the wood with this tool so that a series of holes is left in the wood, or the pattern can be traced on a soft surface. This creates a series of holes in the paper which is then placed over the wood and pounced with a chalk bag containing a contrasting colored powder. It can also be spray painted, but in either case, a series of dots is left on the wood which if necessary, can be connected.

**Illus. 5-11**

77

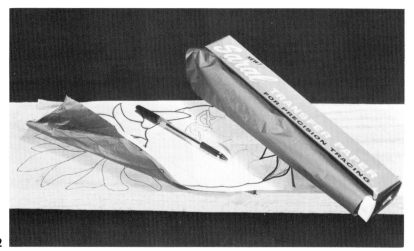

Illus. 5-12

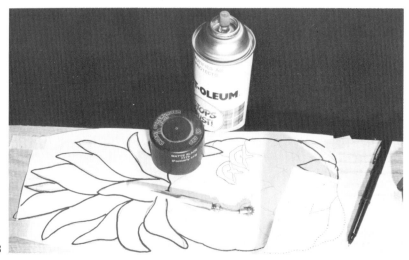

Illus. 5-13

# WORKING WITH PATTERNS

Ideas, pattern enhancement and the difficulties in relying entirely on patterns for high relief carving are illustrated in the process of making a sign. A partial pattern was drawn within a curved-sided triangle established by using the flexible ruler. The leaves (Illus. 5-14) are mirror images drawn on one sheet of tracing paper and the fanciful friend drawn on a second sheet (Illus. 5-15). They could then be overlapped to give the best effect and stay within the overall borders for the sign. The block of wood (Illus. 5-16) was made from 16 lengths of ⅜″ and 19 lengths of ⅞″ redwood face-glued with resorcinol glue. It was trimmed to size and the thicker upper portion contoured prior to application of the pattern. This step is necessary so that the finished project has no hint of a flat surface, a sure sign of unskilled work. The upper part of the pattern was glued

78

Illus. 5-14

Illus. 5-15

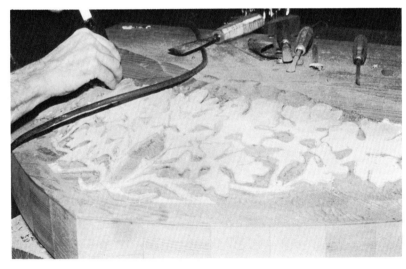

Illus. 5-16

79

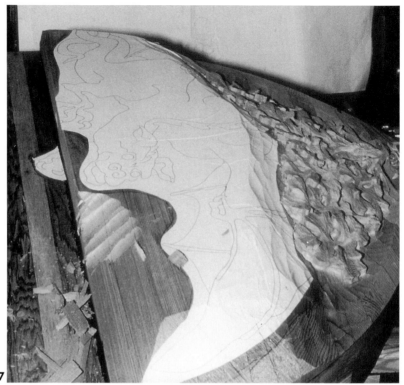

Illus. 5-17

Illus. 5-18

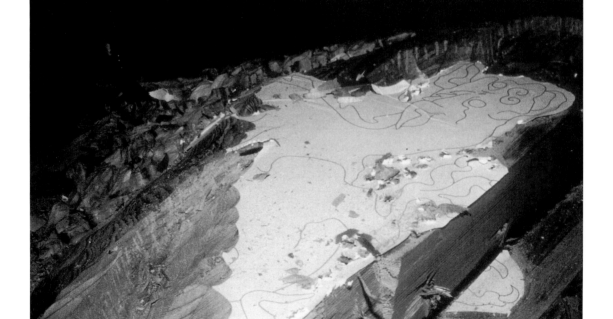

Illus. 5-19

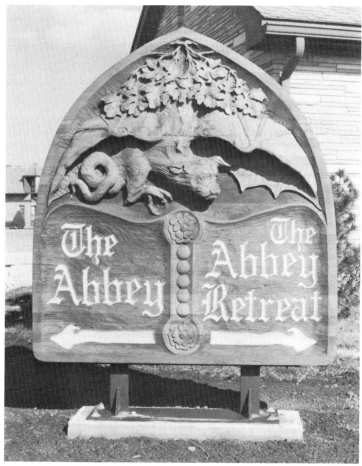

Illus. 5-20. The completed and installed sign.

to this surface using rubber cement and stop cuts made to remove the background and the leaf surfaces carved (Illus. 5-17). The next layer of pattern was then rubber-cemented in place (Illus. 5-18) and the carving continued. After completion of the top half, the center details were carved and the background for the lettering rubber-cemented in position and carved (Illus. 5-19).

A pattern may become a valuable material-saving cutting template as well as the general pattern. A sign ordinance limited the thickness of one sign to 12 inches from the building's front surface, but a backset area for the window allowed an extra 4 inches of thickness at the back of this carving adding up to 16 inches of deep and high relief carving.

A small sketch was made (Illus. 5-21) and then the concept was enlarged into the full size, 4 by 8 feet pattern (Illus. 5-22). Parallel lines, the width of each board, were drawn horizontally on the pattern and numbered. The main panel was made with ¾" and ⅜" lumber, face-glued together (Illus. 5-23). Areas which required a second and third layer were measured and numbered and edge-glued to their corresponding base-layer board (Illus. 5-24). Each of these boards was surfaced and face-glued to make the large carving block, shown with the high relief areas carved (Illus. 5-25). This use of the pattern saved hundreds of dollars by enabling careful measuring and cutting of each layer.

A primary reason for so many distorted and unnatural looking carvings in relief is the direct result of copying a picture or photograph which is in a two-dimensional view, and attempting to carve it in three dimensions. Information is needed on the sides of the object, which levels come out of the pattern, and what areas recede into the wood. Details must be carved not only across the surface, but must continue around the sides as well and, occasionally, completely around. Enough information must be memorized on each subject to mentally see around it.

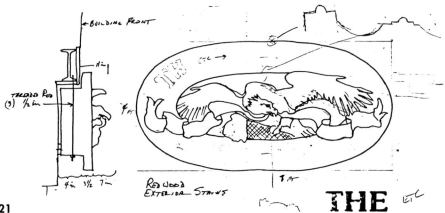

**Illus. 5-21**

82

Illus. 5-22

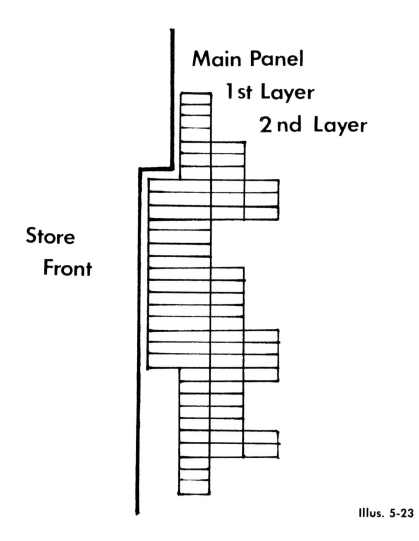

Main Panel

1st Layer

2nd Layer

Store
Front

Illus. 5-23

83

Illus. 5-24

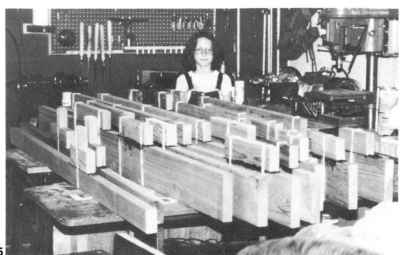

Illus. 5-25

*See color section for completed sign.*

# 6 $W$ OOD

"Which wood is best for carving?" The following points, in the order of relative importance, are what I analyze before I choose the wood species for a project. Sometimes the choice is obvious or even specified; other times, one or two factors will heavily outweigh all others and limit the choices. Occasionally it is a very difficult choice because the same project carved from different species of wood will have entirely different characteristics.

1. The foremost concern is that the design and wood augment each other and reflect the intentions of the artist. The finished project should come as close as possible to the mental image developed during the idea stage. Woods with a prominent grain such as oak and catalpa can overwhelm a project, while patterns with small details and undercutting need a dense, fine and even textured wood such as walnut or maple.

2. The location at which the piece will be displayed, the lighting arrangements, or the surrounding architectural details can each limit the choices of wood. A dark wood on a dark wall or with poor lighting may be totally ineffective.

3. The workability of the wood can make a project a joy to produce or add hours of misery to the job. Using hand planes to prepare large oak boards for edge- and face-gluing because the proper machinery is unavailable makes little sense, but it is feasible with redwood. Woods such as catalpa, basswood, and some mahoganies carve beautifully with knives and gouges, but when very large and thick blocks of wood are used and several hundred pounds of material must be removed, the use of rotary files and burrs will leave a fuzzy surface on them and their roey grain prevents splitting off long

slivers of waste with gouges. Conversely, oak can be worked smoothly and rapidly with carbide burrs.

Sometimes woods considered easier to work with can be substituted for the first choice, but they rarely give equal results. African walnut and butternut appear similar to black walnut, but the texture and density limit the fine detail and finish that is possible with true walnut.

4. The weathering ability is important if the project is to be installed outside. Woods with very little resistance to decay can be treated to prolong their serviceability but in the long run, woods with natural resistance to deterioration such as white oak, redwood, and cedar are best.

5. Dimensional and torsional stability is an important requirement for many architectural applications. Seasonal changes in the humidity will alter the dimensions of a panel made of redwood to a greater extent than a similar panel made of red oak. However, the redwood panel is less likely to warp or twist than the oak panel. Honduras mahogany seems to make panels with the best characteristics of both dimensional and torsional stability.

6. Whichever species of wood is chosen, careful selection of each board is important. The wood must be carefully seasoned and kiln-dried, free of compression or tension and be as straight-grained as possible. Quarter-sawed wood is preferred for special applications such as stiles for doors.

7. The structural strength of carved wood which must carry a load, such as architectural bracing for trusses, or take repeated flexing, as a chair back, will rule out some choices of wood and strongly recommend others. Basswood or redwood would not be appropriate for architecture, while oak or walnut would.

8. In large projects, weight can rapidly approach the limits that one or two persons can handle and larger, more elaborate equipment becomes necessary to move and install those works. It may also be necessary to provide structural supports for large projects which can easily cost far more than the carving itself. Because there is over twenty-eight pounds per cubic foot difference between the lightest (cottonwood) and heaviest (hickory) domestic lumber, and a much greater difference if readily available imported lumber is considered, it is very important to calculate the expected weight of various species of wood.

9. Durability to withstand impact and denting can be important for carved table tops and anything displayed publicly.

10. If you intend to paint the piece, a premium grade wood may not be needed and conversely, a piece to be finished with clear or penetrating finishes requires more attention to matching grain and color of each board.

11. Toxicity and allergic reactions are a consideration for some individuals. Cedar, walnut, and some tropical woods are strong allergens and irritants for many people.

12. Some carvers will spend several hundred hours on a project, but claim they cannot afford to buy the best wood. Actually, the cost difference between construction grade fir and walnut is only two to three dollars per board foot at the very most and for small projects this cost can be insignificant. Price is significant when 1,000 board feet of clear heart redwood is needed, especially if this amount is more than is budgeted for the entire project. Sometimes a less expensive wood such as maple can be carved and stained to match cherry or walnut, but the savings are minimal and may produce a project of less intrinsic value.

# PREPARING WOOD

The principle of drying wood is relatively simple, but can be difficult in practice. A board freshly cut from the log has its inter-cellular spaces filled with water, called "free water," as well as water chemically bonded to the cell-wall fibres, called "bound water." Air-drying a board allows the free water to evaporate; more rapidly with higher temperatures and/or a lower humidity. At a crucial point in the drying process, all free water will be evaporated and the board will be at its fibre saturation point (FSP) which is very close to 30% moisture content for all species of wood. The remaining bound water requires more extreme drying conditions to remove it from the cell walls. This requires storage in an area of lower relative humidity or at a higher temperature or both. It is the removal of bound water from the cell walls which causes the greatest dimen-sional shrinkage as well as an increase in the wood's mechanical strength. Because the wood may be below its FSP towards its outer layers and above its FSP at the center the resulting stress can cause warping, cupping, case hardening, honeycombing and other de-fects. By controlling the rate of drying in a kiln, the stress which causes the majority of damage can be allowed to slowly equalize while the moisture content is reduced to the level compatible with the environment where it will be used which, for most wood carv-ing, is between 6–7%.

As soon as possible after logs are trimmed to length, the ends should be sealed. Wood dries many times faster through the end grain; during the summertime logs will begin to split fifteen min-utes after cutting. Special end-sealers are available and small, short sections can be dipped in melted paraffin, but we have had great success using several coats of water-based enamels or latex paint. Mismatched colors are available at half price from paint stores and the colored ends make identifying your logs and lumber at the mill easier. It is also easier to find and identify boards from the storage pile at the beginning of a project.

After cutting into boards, they are stacked on level platforms off the ground with ½ inch wooden sticks about 24 inches apart be-

tween each layer. Each layer has boards of equal thickness because the weight of the stack helps prevent warping and cupping. Free circulation between the stacks is needed and a tarpaulin is used to keep rain and direct sunlight off the lumber.

A moisture meter is used to periodically monitor the drying process and when these readings reach between 12–15% moisture content, the stack is ready for kiln-drying.

Our kiln will accept about 1,500 board feet of lumber with a maximum length of 11 feet. It has outside controls to turn the dehumidifiers on or off and to reset the remote reading thermostat manually. There are also inlet and outlet vents to remove the large amount of moisture produced at the beginning of a drying cycle.

I was concerned seven years ago about using a room dehumidifier in the kiln and purchased the cheapest unit available. It has run almost continuously since then and it has not yet even needed a cleaning. The furnace blower has been changed once at the cost of a few dollars.

Once the kiln is loaded and sealed, the blower is turned on and after four days the temperature will reach 95°F during the summer and 80°F during the winter because of heat from the blower motor. During this initial period, a large amount of moisture condenses on the cement floor and is drained away. After seven or eight days the temperature and humidity will stabilize and the heater will be turned on and set 10°F above the prevailing reading. The temperature and humidity are allowed to stabilize for five or six days before the temperature is raised 10°F more until a high temperature of 120°F is reached. The humidity is allowed to stabilize at 30% for two or three days. Wood stored at this temperature and humidity will reach an equilibrium moisture content of approximately 5–6%.

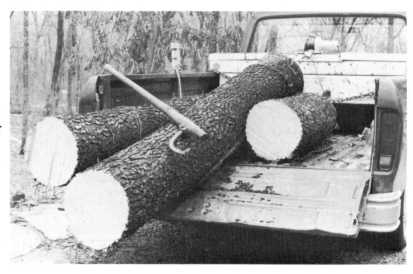

Illus. 6-1. These cherry logs were pulled into our truck with a small electric winch and a ramp. The cant hook is useful for rolling and maneuvering logs into position behind the winch for a straight pull. These small logs weigh a little over 1,000 pounds.

88

Then the dehumidifier is turned off. This allows additional water evaporated from the wood to remain in the kiln which increases the humidity slightly. The moisture reabsorbed by the wood at this time may relieve some of the surface stress resulting from the extreme dry outside layers of wood.

The net result of this effort is a supply of high quality lumber with very few drying defects and a moisture content reading between 6–7%, all for a fraction of the cost of wholesale lumber.

Illus. 6-2. An interior view of a kiln. Mounted on the center portion are two wet and dry bulb hygrometers and a direct reading hygrometer and the furnace blower. Plastic sheeting is used to seal the partition down to the wood pile so the heated air circulates between the layers of wood.

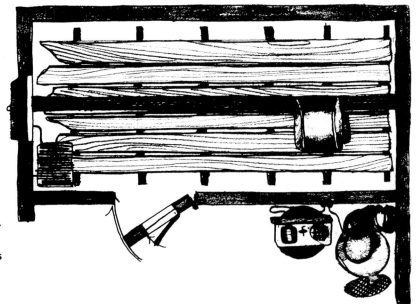

Illus. 6-3. Looking down into the kiln shows the access door with its accessory door to view the hygrometers while the kiln is on. A small window at the end of the kiln is used to load and unload the boards straight on to or off a truck. The dehumidifier and 5 KW electric heater are mounted to the ceiling. The electric heater is controlled by a remote bulb thermostat with a range of 40 to 180°F.

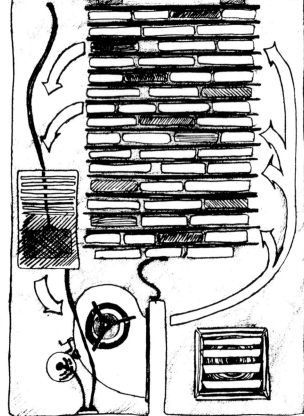

Illus. 6-4. The side view shows the air flow through the stack of wood. Sticks of wood, 1/2" thick and spaced 24" apart, keep each layer of wood separated and plastic sheeting is stapled and weighted to form a seal between the middle partition and the top layer of wood.

# 7 ADHESIVES

Regardless of the attributes and qualities of any particular adhesive, the *quality* of joinery will determine the strength and longevity of a joint more than anything else. Edges and faces must fit together with a very small degree of error, and with a minimun of stress, to be most effective. Even if two pieces of wood with a poorly machined glue joint are forced together with heavy clamping pressure, the wood will eventually split along natural fracture lines in the wood itself. It should also be remembered that a board, even without a glue line, is capable of generating an incredible amount of stress with changes in humidity. This stress is only compounded when it is mated with another board whose grain structure and orientation, moisture content and predilection to cup, warp or twist is different.

Obvious, but often ignored, is proper and accurate measuring, either by volume or weight, of the quantities of multiple-part adhesives and the thorough blending of the ingredients before application. A small paddle mounted in a variable speed electric drill or paint mixer work well. The material clinging to the sides and bottom of the container should be mixed into the main bulk several times. Some mixtures, epoxies in particular, can be mixed easier if placed in a microwave oven for a few seconds. Care must be taken because epoxies cure by heat and, in large volumes, this heat cannot dissipate fast enough and a quart or more mixture can set in the mixing bowl in less than a minute. It may therefore be necessary to spread the epoxy in a shallow pan or place the bowl in another bowl of ice and water after mixing while it is being applied to the project.

Paint rollers and brushes, spatulas, notched trowels, and rubber squeegees are used to spread a uniform layer of adhesive, usually to both mating surfaces, as quickly as possible. On some large projects, because adhesive must sometimes be spread over a hundred or more square feet of edge and face surface, the project may need to be done in several steps. In any case, a project should be clamped together without glue so each clamp needs only a turn or two to tighten so you can be sure that each piece fits properly under moderate clamping pressure. The time to rehearse the spreading and clamping procedure has always paid off. This is because adhesives have two important time limits. Ignoring or being unaware of them can, at best, cause a premature set up and loss of expensive adhesives and at worst, cause dry joints with subsequent delamination of joints with cured adhesive preventing any further mating of surfaces during clamping.

The first, open pot life, refers to adhesives mixed and ready to use. White and yellow glues come ready-mixed and have unlimited pot life. Epoxies will have an hour or so if kept cool then heated slightly with lamps to spread. Resorcinals on the other hand, may have a pot life of 2 or 3 minutes.

The second time limit, the closed assembly time, is why a dry clamp rehearsal is necessary before application of adhesive. White and yellow adhesives cure by loss of water, either to the surrounding air or wood. When adhesive is spread onto the mating surfaces of two boards which are placed together but not clamped, the evaporation of water to the air is reduced, thus extending the time before clamping is necessary and making it possible to spread adhesive on more layers.

Epoxies take much longer to cure as a thin film than they do as a thick mass. Contact cement, rarely used for wood joinery, does have the advantage of requiring time to completely dry before the surfaces are mated together. Some of the new instant adhesives are formulated so each surface is spread with either the substrate or the activator, and cure is delayed until the surfaces are joined and pressed together. Silicone rubber, which we have used for years for outdoor signs, needs to be joined rapidly because it remains pliable for a period of time, but skims over within five minutes, preventing adherence to the second surface. If two pieces of wood are pressed together immediately it will allow a reasonable assembly time before final nailing or screw-fastening of the joint.

Most adhesives are designed to work best when the room and wood temperature is at or near 70°F and the humidity is average. At colder temperatures some adhesives, resorcinal for example, will fail to develop full strength and at higher temperatures most will have too short an open and closed assembly time for anything but edge gluing small panels. There are epoxies designed to set properly at temperatures down to freezing which are useful for work in an unheated shop.

The moisture content of the wood is another factor. Adhesives which cure because of water loss will be slow to set or have a joint of marginal strength if the wood is above its fibre saturation point. A moisture content of 5 to 12% is considered best. But there are epoxies designed to set even underwater.

Individual wood species can make gluing blocks of wood difficult. Dense woods may not allow enough penetration to saturate a layer of wood fibres and may need wiping with water or an adhesive compatible solvent to form a high quality bond. The tannic acid in oak is said to react with casein adhesives and eventually cause joint separation. Woods rich with extracts such as teak and rosewood will inhibit adhesion and require a solvent wipe before application of adhesive. Open-pored wood such as oak may absorb adhesive fast enough to starve a joint and sometimes require the use of more viscous adhesives or a coat of sealer which is allowed to cure followed by light sanding and a second application of adhesive and clamping.

For most interior applications the common yellow glues are satisfactory. They have a very long shelf life, reasonable open and closed assembly time, and certainly form joints as strong as the wood itself. Parts can be soaked in water to disassemble, if necessary, a characteristic useful in furniture and instrument repair. Possibly a slightly stronger and more water-resistant joint is possible with the plastic resin adhesives which require mixing with water before use. The latter may require less clean up of glue that is squeezed out around joints before finishing; a real problem with yellow glues.

A characteristic of yellow glue as well as hide glue is called "creep." Lumber stock with radial and tangential grain, jointed and glued together with these glues will expand and contract at different rates with changes in humidity. During the summer months, an edge can be felt at this glue line. Without loosing the bond, the glue stretches, so to speak, and allows the wood to move. Part of the dissatisfaction with early epoxies was the hard, brittle bond formed which prevented any natural movement of wood and occasionally resulted in a fractured glue line. The new epoxies were designed for the aircraft and marine industries where flexing is unavoidable and often necessary.

If a reasonable guarantee is to be offered for exterior work, a weatherproof adhesive must be used. Resorcinal is used for cedar or redwood provided its dark red glue line is not objectionable, or house stains or paints are to be used.

Where a waterproof glue line, great structural strength and a gap-filling ability is required, epoxy is the first choice. Time has proven that the use of silicone adhesives is a good choice for large outdoor pieces. The construction adhesives available for use in caulking guns are indispensable. They are fast, easy to use, waterproof and form strong bonds.

For clean, fast repairs, the five-minute epoxies are good, al-

though they are not as strong or weather-resistant as regular epoxy. The new cyanoacrylates or so-called "instant" glues are available now in a viscous form less apt to soak into a porous surface such as wood. These are also two-part systems in which both surfaces are coated with different components and bonding starts when these surfaces are mated together. Neither is gap-filling, but both seem to do an excellent job for repairing a clean break.

A relatively recent import from Europe are the liquid polyurethane adhesives. They form a waterproof bond by utilizing the moisture in the wood itself, expanding as it dries. They have a very good assembly time and from strong bonds.

There are two important concerns when clamping and gluing a large project. First, make sure all joints fit together with as close a tolerance as possible. This must be carefully watched when edge-gluing and face-gluing at the same time. Secondly, it is not a good practice to bring parts together with great pressure from a few clamps. Instead, using as many clamps as possible, each applying a moderate, well-distributed pressure, is much more effective.

At various times in our studio clamping tools include large elastic bands, bicycle inner tubes wrapped around the edge of panels and inflated, an automobile raised and lowered with four jacks, and adjustable floor jacks between the ceiling and project.

Even for simple projects, a dry run, clamping each layer together and then each level together, can prevent much grief later on. During this rehearsal, one should anticipate how the boards will move when lubricated with adhesive and estimate how many surfaces can be coated with adhesive and placed together within the assembly time limitation.

A great variety of paraphernalia is required for measuring mixing and spreading adhesives (Illus. 7-1). Scales and measuring cups are used for measuring the components of various types of adhesives. A syringe is used to measure small volumes of catalysts. Small and large paint mixers are used to thoroughly blend the components, and trowels (straight or notched), brushes, rollers, pads, and spatulas are used to spread adhesives. Syringes are used

**Illus. 7-1**

94

**Illus. 7-2. Elastic bands of all sizes, small chips and hemostats, lead weights and wishful thinking are all used to hold odd-shaped pieces of wood in place long enough for an adhesive to set, hopefully resulting in an invisible glueline after repair and clean-up.**

to place glue in tight spots. Waxed paper goes between clamping blocks and other areas where bonding of wood is undesirable. The heat lamp is used to warm the wood surface and adhesive to facilitate wetting and occasionally to accelerate the cure. A good waterless skin cleaner is the only way to remove uncured epoxy from the hands.

# 8 *T*OOLS AND SHARPENING

The folklore of wood carving is rich with lengthy discussions on knives, sharpening, and techniques for use.

Almost any brand of carving tools will provide adequate service, but small sets and handles with interchangeable blades are useless and often dangerous for anything but the smallest projects. Some brands will have excellent steel and a wide variety of styles, but require regrinding of the inner surface to make sharpening easier (Illus. 8-1).

During the course of a normal workday, dozens of knives are used, but there is no special technique or secret for how to keep each one razor-sharp. Each new knife, whether homemade or purchased, is sharpened and used for a period of time. If a thin bevel is too fragile for its intended use, it is resharpened with a shorter bevel and used until a compromise between edge-holding ability and ease of pushing through the wood is reached. Because much of the knife destroying work of rough-out and stop cuts is done in our studio with gas, electric and air tools, the maintenance of sharp edges requires a few seconds of buffing when cuts begin to be ragged. Sweeps and sizes used most often should be duplicated, each with a suitable edge for softwoods such as redwood or hardwood such as oak.

Carving tools can be ruined by sharpening on grinding wheels

A 6'8" × 4'6" × 6" lined white oak project which features stained glass. Once upon a time, a client chose cherubs, swans, and daisies and wanted them all tied together with a ribbon to be featured on the client's Pebble Beach house. The ribbon ends in a carved bell that rattles when the door is closed.

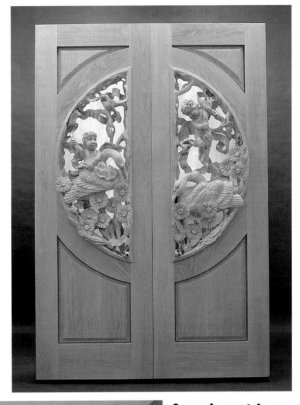

Seven-foot × 6-foot × 3-inch white oak and wrought-iron Bavarian crest doors.

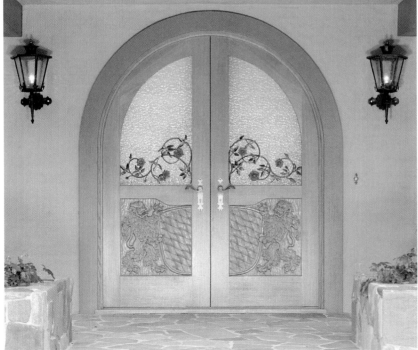

A

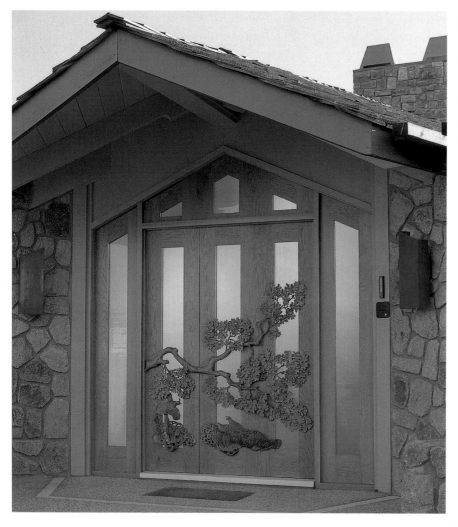

A 7' × 6' × 9" white oak project featuring textured glass and geodes. These quails playing under an oak branch have bronze top knots. The door itself has an automatic locking device to the side of it to eliminate visible hardware. Photo courtesy of Tom O'Neal.

A 7' × 6' × 5" red oak project featuring glass and polished geodes. This grove of big-leaf maple trees shows an above and below ground view of the trees. Contained within the root system, polished sections of geodes have been imbedded. Photo courtesy of Tom O'Neal.

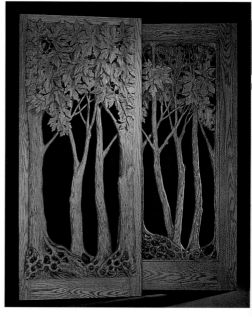

B

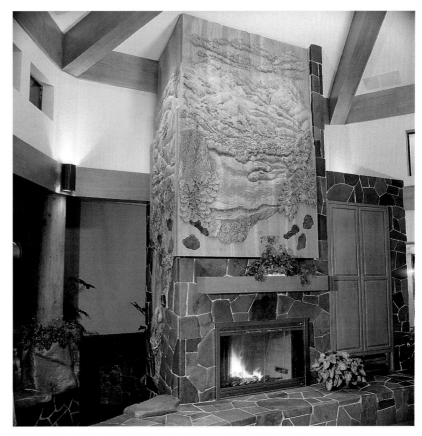

A 14' × 9' × 8" wall relief and side panel made of white oak and stone. It depicts the client's place of birth, a village in Bavaria. The side panel represents elements of his present home. Photo courtesy of Tom O'Neal.

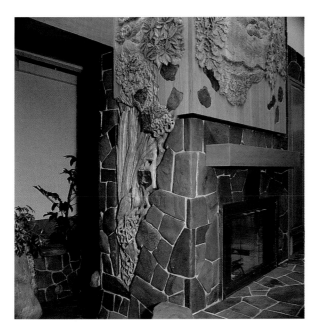

Detail of the side panel.

C

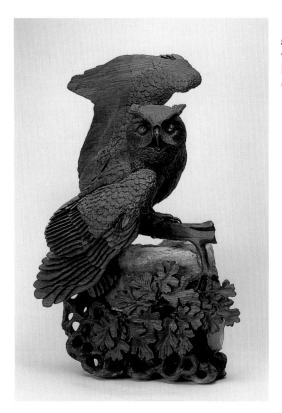

*Things That Go Bump in the Night* sculpture. It is 27″ × 14″ × 12″ and is made of walnut and Monterey chalk rock. The great horned owl plays a part in many religions. Photo courtesy of Tom O'Neal.

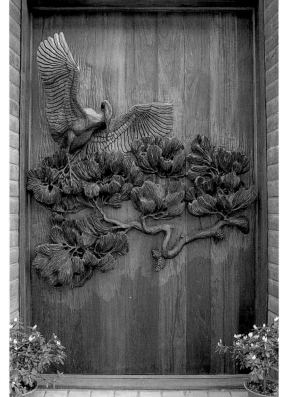

An 8″ × 5″ × 11″ teak panel. This snowy egret and Monterey pine combination reflects the Oriental taste of the owner. There is an intaglio carving of a cypress tree on the inside. The door design contains the pull and includes a touch pad lock which automatically opens and closes the door. Photo courtesy of Tom O'Neal.

D

Illus. 8-1. Many carving gouges of high quality may have irritating irregularities which make sharpening difficult. High or low grooves on the inner surface, exaggerated here, will leave a corresponding point or dip in the final edge. It is necessary to regrind and polish this surface with small wheels to facilitate future sharpenings.

because the heat produced draws the temper from the thin edge, reducing it to soft iron which immediately dulls when used, requiring further sharpening. Each such grinding can remove years of use from the tool needlessly. It is possible, even with hand sharpening on a Japanese waterstone to produce enough heat to produce steam. A little practice and a good file works best to define the primary bevel.

Rough-out work is usually done with chainsaws, if necessary, and then pneumatic die grinders and rotary files. Large electric die grinders and even router motor heads, used as die grinders, can be used, but the heat generated and the tremendous torque make their use very dangerous. If a rotary file caught or started to bounce, when used in electric tools, its shank would break or a lot of extra wood would be ripped away. Air tools, on the other hand, can be adjusted to stop before trouble begins. Stop cuts are made with electric drills and bits for large projects and with small pneumatic pencil grinders or the Dremel Moto-Tool using small dental burrs which will cut along a pencil line almost as fast as drawing and cause less damage to the surrounding wood than other methods. There is a tremendous time savings with these tools, especially if the stop cut is 2 or 3 inches deep.

All rotary files and burrs will produce nothing but chatter, frustration and a very poor quality cut at speeds less than 14,000 RPM. Keep this figure firmly in mind when reading about flexible shafts for use with electric drills or attached motorized flexible-shaft units.

Vibrating power carvers which use small blades take two to four times as long to accomplish the same cut as simply pushing the

gouge through the wood. Equal or better accuracy is maintained by blows with the palm or a small mallet. They may be useful to those with a limited range of motion in their arms or hands, however.

Because wooden mallets lack enough mass to prevent transmission of vibration to the wrist, you can use brass mallets which transfer the damage to the tool handles. The handles can be easily replaced with blocks of ash and quickly sanded to shape. A resinous hand paste sold in sport shops is used to better grip the knife handles and mallet. A palm guard cut from scrap leather prevents blisters from the handle end when pushing gouges through wood.

A wide variety of sharpening stones are useful: carborundum oil stones, soft and hard Arkansas stones, round and triangular tapered India stones, leather strapping, a good file, a Japanese waterstone, a tapered round-edge hard Arkansas stone, and a buffing wheel charged with white rouge. Smaller tools can be finished with a combination stone and leather strap made for straight razor maintenance. The inside surface of small veiners and parting tools are honed with 600 grit carborundum paper.

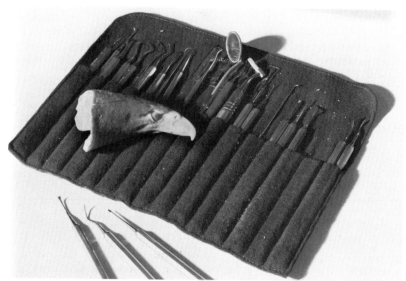

Illus. 8-2. A set of small dental picks, scrapers, and files are used for very small and detailed carving on hard, dense wood such as ebony or on materials such as sperm whale tooth.

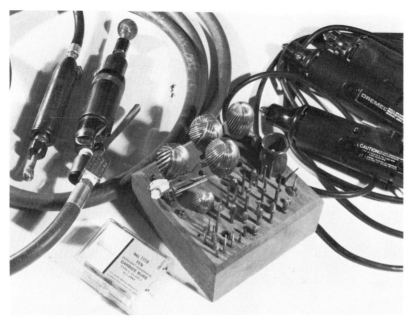

Illus. 8-3. Stop cuts and heavy roughing out, two procedures which cause the greatest damage to thin edges, especially when working extensively in oak, are done primarily with various electric and pneumatic tools.

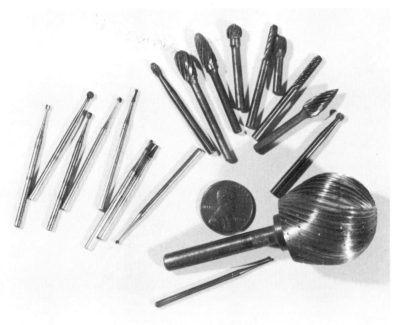

Illus. 8-4. Various shapes of carbide burrs and rotary files ranging in size from 0.40 to 1¹⁄₁₄″ are used.

Illus. 8-5. Because of the variation in density of woods, gouges with the same sweep and size are used but their profiles and length of bevel will be different. The corners on one will be kept sharp and square while the other will be rounded over. Because these knives are used daily for years with only occasional buffing to maintain the sharp edge, the back bevel becomes rounded, but the quality of the cut is the important factor.

Illus. 8-6. Sharp corners on the left gouge leave an edge to the cut when they are below the surface of the board. Rounded corners on a gouge with the same sweep produce the same surface texture with fewer cuts and rough edges.

Illus. 8-7. An edge will need regrinding when it looks like this.

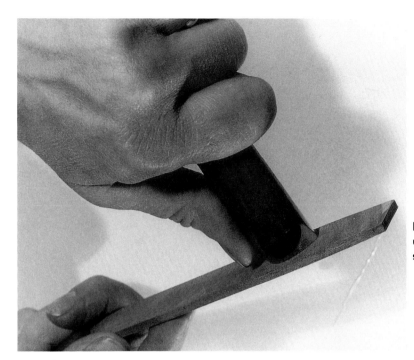

Illus. 8-8. A good file is used to flatten and square-up the edge.

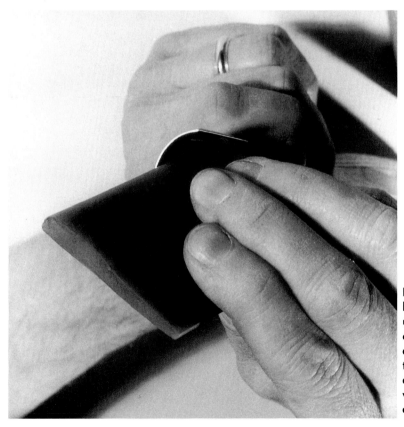

Illus. 8-9. A round-edge hard Arkansas stone is used to remove the wire edge from the inside and outside bevels so that the actual thickness of the edge can be watched during subsequent filing.

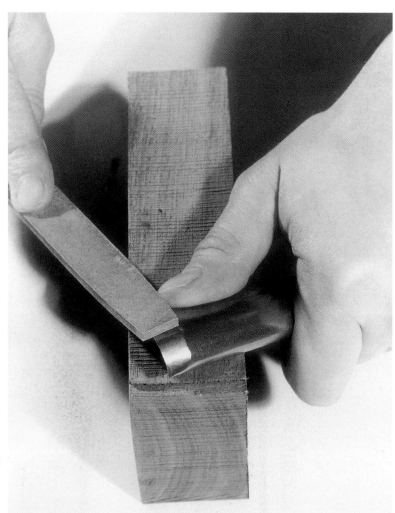

Illus. 8-10. The back bevel is filed evenly until a thin wire ridge can be felt along the entire length of the edge, usually by pushing the thumbnail off the end.

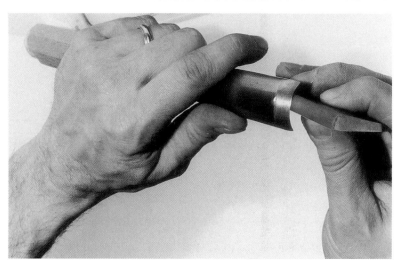

Illus. 8-11. A hard Arkansas stone removes the wire ridge to make sure no flat areas remain.

102

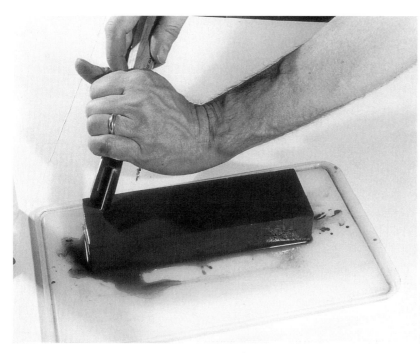

Illus. 8-12. An 800-grit Japanese waterstone is kept flooded with water to maintain a slurry of cutting material. The handle of the gouge is rotated and moved across the stone until this bevel is even and a new, small wire edge is formed.

Illus. 8-13. A cloth buffing wheel is charged with white rouge and the outside bevel is kept tangent with the wheel.

103

Illus. 8-14. The gouge is rotated for a few seconds to begin the final polish.

Illus. 8-15. The inside bevel is held tangent to the wheel and polished for a few seconds.

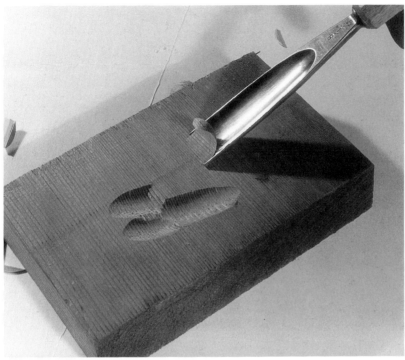

Illus. 8-16. Because the sharpness of the gouge will be maintained by periodic buffing, it is not necessary to remove all marks left by the stone. When it is sharp enough to easily cut across grain in a block of redwood or shave a section of the forearm, it is ready to use. The entire process takes less than 15 minutes.

Illus. 8-17. Small gouges and parting tools can be buffed carefully with cloth or felt wheels charged with white rouge. Care must be taken on these tools not to round off the corners or to buff too long.

105

# 9 $F$INISHES

An untreated surface, with a few exceptions, soon becomes dirty and coated with grime and a gradual process begins which will reduce the wood into its basic elements. The primary purpose of a finish is to slow this process down.

Finishes for carving can rarely be applied and treated the way furniture makers suggest. They deal with flat surfaces and strive for a smooth, flawless look, while wood carvings are rarely sanded, have surfaces of infinite combinations of long- and end-grain and in most instances tend to emphasize textures and grain irregularities. Occasionally, the finish is expected to furnish structural support for thin and fragile parts of carvings.

A carver should buy a small sample of any stain, oil, or finish that seems interesting and give it a try. I treat several scraps of various woods with new finishes and toss them on the roof. Each spring when the woodstove chimney needs cleaning, I can check the results against the claim on the label.

## INTERIOR FINISHES

The fastest, easiest and most acceptable finish, especially for walnut, is penetrating oil finish. Linseed oil and turpentine is the worst.

The more porous woods such as mahogany or oak usually require a surface coating. I have never used a wood filler. I find a sanding sealer an easy way to achieve a smooth, but very nondurable finish. For many years I have used plastic oil and polyurethane in various

ratios to achieve a compromise between a penetrating and surface coating. Several coats of undiluted polyurethane gives an undesirable plastic look to a carving. My standard finish is an oil/polyurethane mixture beginning with oil, then 75% oil: 25% polyurethane and, if necessary, depending on the porosity of the wood, 50% oil: 50% polyurethane to fill and seal the wood. This is followed by one or two well-brushed coats of absolutely flat polyurethane, a combination which gives the best protection as well as the best representation of unfinished wood.

Occasionally some staining is necessary to blend colors of individual boards and alcohol- or lacquer-based stains work best. Alcoholic extracts of each species of wood are used to stain sapwood.

A wide variety of colored stains can be used to achieve subtle effects. Stains with different solvents and colors may give entirely different effects on different woods. Any end-grain will stain much differently than flat-grain; therefore, it is prudent to dilute a stain and build the color intensity desired with several applications to avoid the dark, splotchy end-grain contrasting with the unstained flat-grain. Scrap wood from the project should be carved at various angles to the grain and used to experiment on until the desired effect is achieved. There are no universal stains. Remember that oils, acrylics, and any paint becomes a stain if diluted enough with its solvent. Many stains and colors will fade rapidly if exposed to sunlight.

Because clear epoxy will darken and highlight wood the same way oil or clear finishes will, it can be used very effectively to fill surface imperfections on wood. The color and grain pattern can be seen through the epoxy layer, so it makes an invisible repair after the entire surface is finished. It is far superior to the usual wood paste or glue and sawdust patch. A heat lamp can be used to liquefy the epoxy, allowing better penetration and letting bubbles rise to the surface.

# EXTERIOR FINISHES

One of the best exterior finishes is in actuality no finish. Redwood and cedar, white oak, and osage orange are a few examples of woods which will remain intact for a considerable length of time.

When using colors on untreated wood signs, they should contrast with the weathered wood. Remember that fresh-cut boards which are dark colored will lighten and light woods will darken with exposure to sunlight. Finishes are available which will accelerate this reversal of color. It is possible, for example, to quickly and evenly turn redwood or cedar a weathered silver color, or to reverse this silver grey color back to the original brown color. These types of penetrating finishes are referred to as clear wood finishes. They are formulations of a solvent and, usually, pentachlorophenol, varnish,

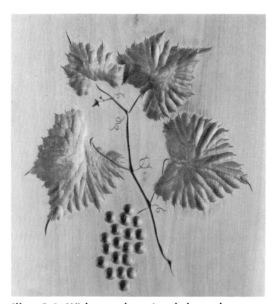

Illus. 9-1. Without other visual clues, the eye has difficulty in distinguishing whether these leaves and grapes are carved out from the background or into the background. They are actually carved intaglio, or into the panel. It takes about 20 minutes to draw and carve these designs.

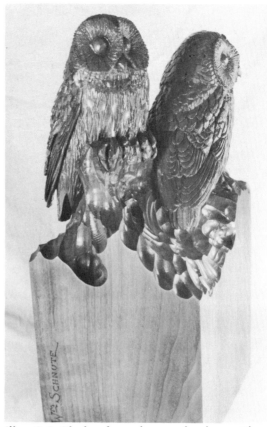

Illus. 9-2. Blocks of wood were glued up with the more patterned grain towards the bottom and straight grain for carving towards the top to create this pair of saw whet owls. Walnut, 1976, 6″ × 7″, 5″ × 14″.

Illus. 9-3. A third element in the design of a sign may add further information to the overall theme or merely break the monotony of a large expanse of background. The effect can be achieved with color, a change of texture or a change in the depth of the background. The raised relief of the eagle and crest was highlighted by the shallow relief, fleur-de-lis carved into the background, and gilding. Walnut, 1974, 12″ × 24″ × 1″ and 2″.

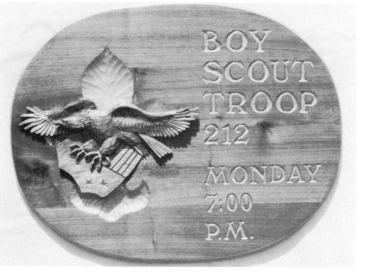

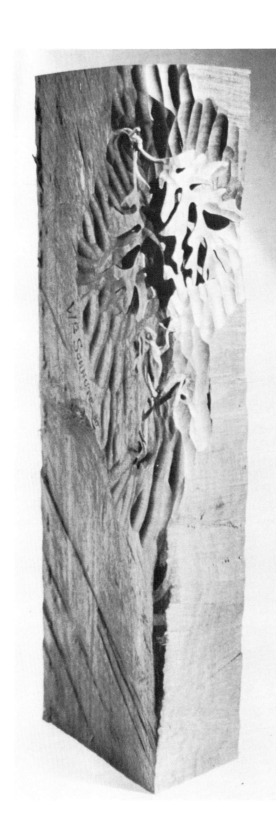

Illus. 9-4. An old walnut tree not commercially useful for lumber was milled with a chain saw into large planks which were air dried several years and then kiln dried. Because they were very irregular in thickness, a great deal of wood would have been wasted if they were surfaced flat and parallel. It was decided to joint one edge and leave all the surface irregularities on the other surfaces to add contrast to delicate and detailed carving such as this tree frog and oak leaves. Walnut, 1980, 3.5″ × 6″ × 19″.

Illus. 9-5A

Illus. 9-5B

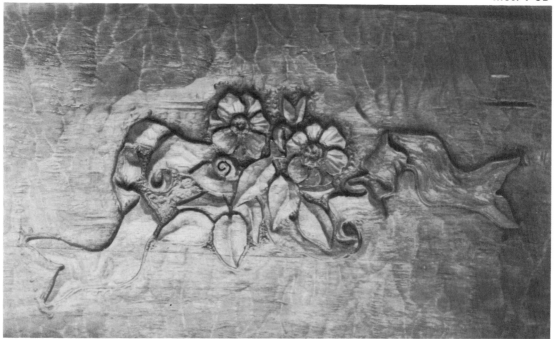

Illus. 9-5A & B. As many times as possible, elements of surprise are included in carving projects. Some, as the sign shown in 9-5A, present a level of information when viewed from a distance, fulfilling all the functions of a sign. But when viewed close up, as shown above, it reveals a small carving of a wild rose with a ribbon that has been included strictly for those who are curious enough to get closer. Redwood frame and walnut, 1981.

Illus. 9-6. A small frog on lily pads was carved on top of a fireplace mantel, out of sight of everyone less than 6 feet tall. Sometimes even the owners are not aware of such inclusions. Honduras mahogany, 1981.

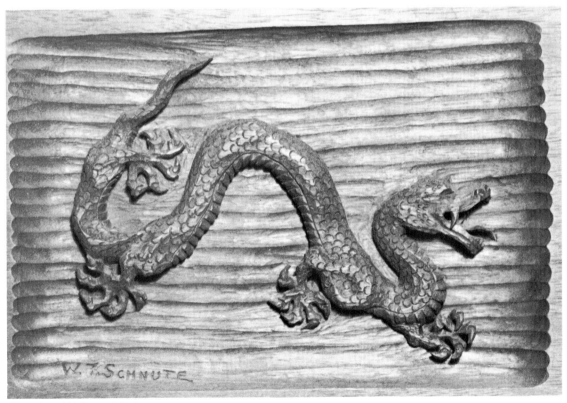

Illus. 9-7. Walnut, 1969.

and paraffin to which pigments can be added for special effects. These products are available ready-to-use and are one of the best exterior finishes available. Maintenance is easy. A liberal brushing, rolling or spraying of more finish is all that is needed. Many brands are hazardous to plant and animal life, so precautions are necessary to avoid splashing or overspray.

Several coats of clear wood finish and preservative should be applied to saturation and allowed to cure on most exterior work and signs. House stains or high quality sign painters' enamels are then used to finish the project.

The bright, clean look of varnished oak or walnut cannot be maintained outdoors. Sunlight, specifically the ultraviolet wave length of light, reacts with and destroys lignin, the natural binder holding wood cells together. Wood immediately below a clear plastic finish is destroyed causing the finish to blister and peel off, allowing moisture to penetrate under the remaining finish, producing staining and more rapid destruction. Varnished work shaded from sunlight, however, will last for years. One redwood sign, in place for eight years, has had its front side, exposed to continuous sunlight, refinished four times while the back side, shaded by evergreens, is still as sound as the day it was installed. Varnish forms a tough, hard coating which stays clean but tends to crack with normal expansion and contraction of wood, allowing moisture to enter behind the finish. Polyurethane forms a tough, flexible finish, but tends to become white and chalky after a year of exposure.

A new system now being tested involves using epoxy sheathing resin filled with 10-20% mica powder absorbed into the wood to form a moisture barrier and an ultraviolet absorber. The epoxy is protected by several coats of exterior varnish or polyurethane.

Gold leaf certainly offers exciting possibilities and is an excellent exterior finish and some of our most elegant signs are of walnut with gold leaf lettering.

Finishes can be used to provide more than a bright, clean and protected surface. Wood stabilization or repair may be of equal importance. Polyethylene glycol, especially of low molecular weight, PEG 1000, for example, a water soluble waxy substance is used as a solution to soak green wood, especially burls and thin cross-sections of logs, to prevent dimensional shrinkage and the resultant splitting.

Fragile and thin sections of carvings can be strengthened by saturation with epoxy resin diluted 10% with lacquer thinner and rotten wood can be saturated with epoxy sheathing-resins. After cure, the rotted wood will be stronger and more stable than the adjacent good wood.

# 10 SHALLOW RELIEF

The basic techniques of carving shallow relief, deep relief and high relief are essentially the same. The tools may be bigger and more powerful as the work size increases, but there will be stop cuts which separate the background, or wood which is reduced to the bottom of the panel, and wood from which the actual carving is to be done. On some work the background is cut through or pierced and a band saw or saber saw accomplishes this neatly.

The basic sequence for the design and carving of the small sign described here (Illus. 10-32) represents one day of work. It was carved in red oak, 18 × 30 × 1¾ inches.

A frozen mallard duck (Illus. 10-1) was borrowed from a taxidermist to provide the necessary details for a pattern. Several positions were sketched before the final sign profile and layout was established (Illus. 10-2). It was important to allow space for a variety of lettering combinations. White oak was selected because of its excellent weatherability and its rarity for sign use. Boards were thickness planed, cut to approximate length, and matched for grain pattern and direction. Using the pattern outline, a smaller block of wood was aligned for the head. A perpendicular line was drawn across each board to facilitate clamping and each joint was marked with an "O" and "F" (Illus. 10-3).

Each board was jointed just before glue-up insuring a clean surface, the "F" against the fence of the joiner and the "O" on the outside so any error is cancelled if the fence was not exactly perpen-

Illus. 10-1

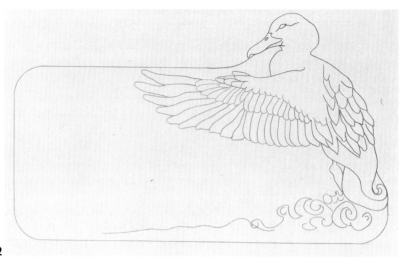

Illus. 10-2

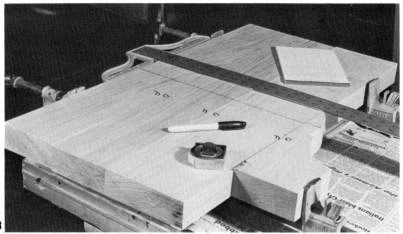

Illus. 10-3

114

Illus. 10-4

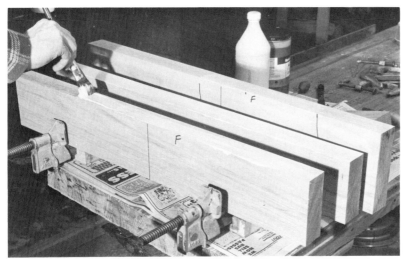

Illus. 10-5

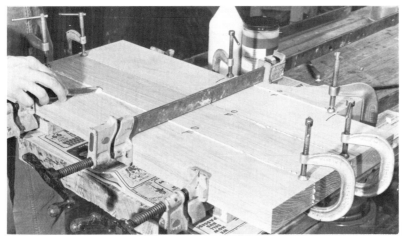

Illus. 10-6

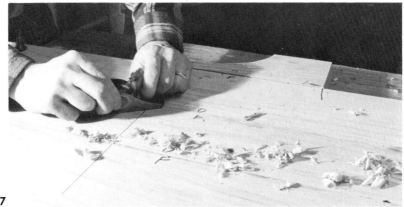

Illus. 10-7

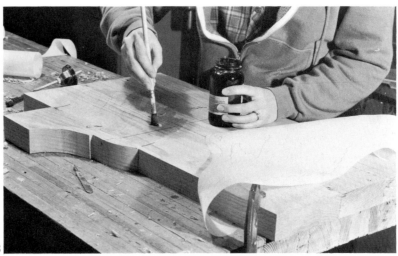

Illus. 10-8

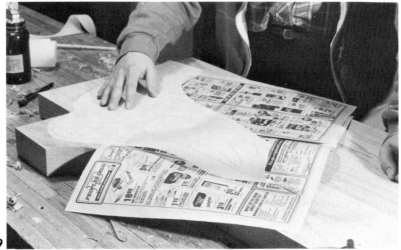

Illus. 10-9

116

dicular to the table (Illus. 10-4). Because of its rapid cure, casein adhesive with catalyst was mixed thoroughly and brushed on both surfaces (Illus. 10-5).

Boards lubricated with glue tend to slide out of alignment unless preclamped with "C" clamps (Illus. 10-6). After cure, the glue lines were scrub-planed level (Illus. 10-7) and the paper pattern was rubber cemented in place, coating both paper and wood (Illus. 10-8). Newspaper was placed between pattern and wood until the pattern was aligned because the pattern will adhere the first place it touches the coated wood surface (Illus. 10-9).

Illus. 10-10

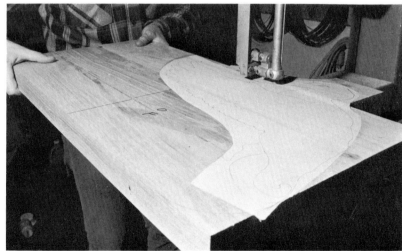

Illus. 10-11

117

Anything handy is used to radius the corners (Illus. 10-10) and the outline is band-sawn (Illus. 10-11) and sanded to shape (Illus. 10-12).

The piece was attached to a hydraulic positioning vice and suitable tools for the initial rough-out selected (Illus. 10-13). A border was drawn around the perimeter of the sign (Illus. 10-14) and carving began.

A stop cut is necessary between the background or wood that is to be removed and wood that will be shaped and carved, in this case, a wing (Illus. 10-15). Traditionally, a vee-shaped parting tool is used, but the depth of the cut can be only about half the width of the side. When working with oak the tool is dulled and chipped easily. A series of cuts can be made along the line with a gouge, but the process is slow and the cut must be made repeatedly to achieve any depth (Illus. 10-16). In softer woods, fibres of wood are crushed by

Illus. 10-12

Illus. 10-13

118

Illus. 10-14

Illus. 10-15

Illus. 10-16

119

the back bevel so the first series of cuts are made away from the pattern line and a second set of cuts is needed to trim excess wood to the pattern edge. An alternative method, more useful in large pieces, is a series of drilled holes (Illus. 10-17). Tape on the drill bit marks

Illus. 10-17

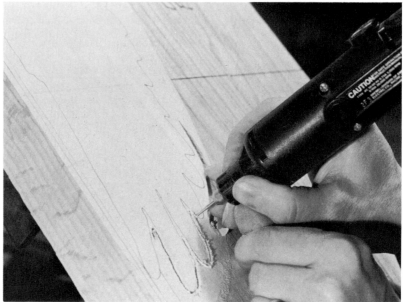

Illus. 10-18

120

the depth and the background can be carved and split off with little damage to the remaining wood.

The fastest, most accurate method to achieve a narrow, deep and clean stop cut is with small carbide burrs, available from dental supply houses, mounted in an electric die grinder (Illus. 10-18). Asking your dentist for some used burrs should provide a variety of sizes to try. The coarser burrs work better and burn less. After the initial cut, the burr will automatically follow the line and several passes can be made for greater depth. On larger panels, a router should be used.

After the stop cuts were made (Illus. 10-19), the background was reduced by splitting off large sections (Illus. 10-20) and then texturing the surface (Illus. 10-21). Large rotary files used in pneumatic die grinders are also useful to speed this task (Illus. 10-22).

It was intended that the edge of this sign be the full thickness of the board and the narrow border surround the sign with a pillowed background left to carve the lettering into (Illus. 10-23). High and low areas and the directions of curved areas are mapped out on the wood and the general shape and form of the subject can be quickly roughed out (Illus. 10-24). This step is probably the most critical of the carving process. The basic form must be pleasing and correct. An excess of detail added later will rarely compensate for a lack of attention at this stage.

A wing pattern with feather detail was glued onto the contoured surface (Illus. 10-25) and stop cuts made at the forward edge of each feather. Each surface was carved with a variety of gouges leaving a

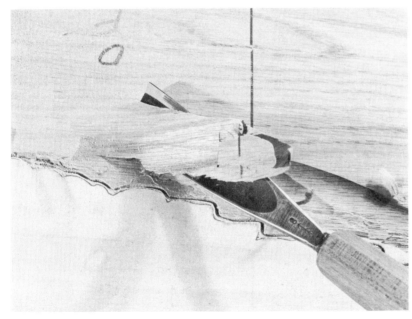

**Illus. 10-19**

121

clean texture (Illus. 10-26 to 10-29). The stop cut and the accumulated attached chips were trimmed off with small parting tools or veiners (Illus. 10-30).

The eye position, tail feathering, feet and water splash were drawn on the wood and carved using a variety of gouges and spoons (Illus. 10-31). Light stains were added to increase visibility and lettering was carved into the background before a polyurethane varnish mixture was applied (Illus. 10-32).

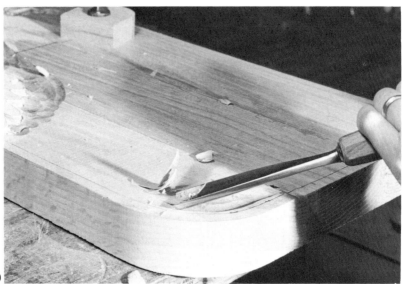

Illus. 10-20

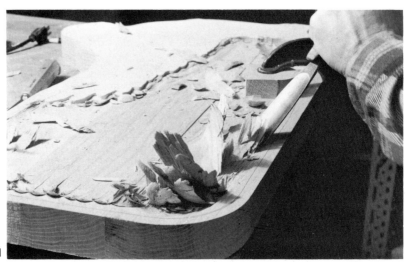

Illus. 10-21

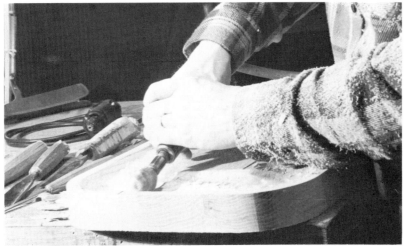

Illus. 10-22

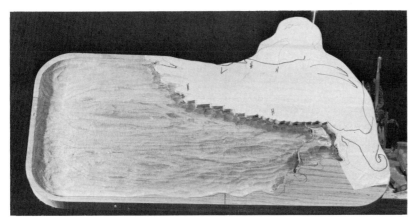

Illus. 10-23

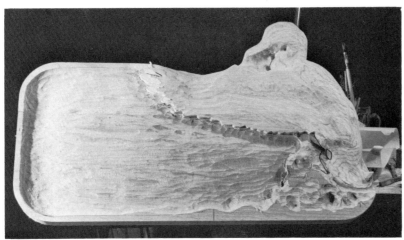

Illus. 10-24

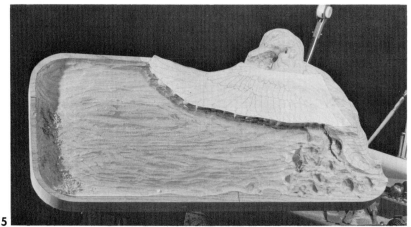

Illus. 10-25

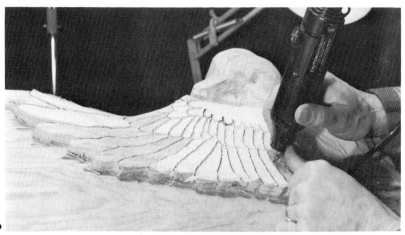

Illus. 10-26

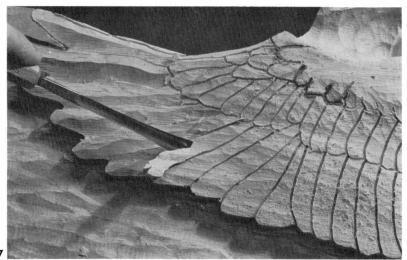

Illus. 10-27

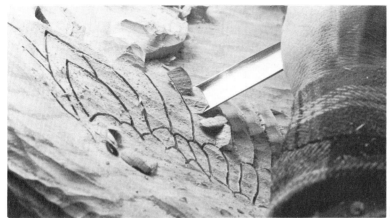

Illus. 10-28

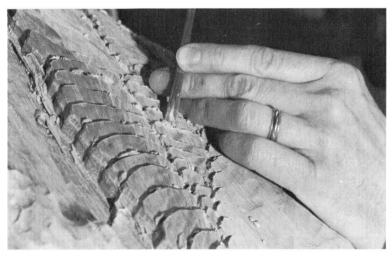

Illus. 10-29

Illus. 10-30

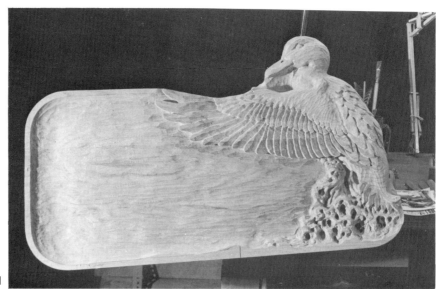

Illus. 10-31

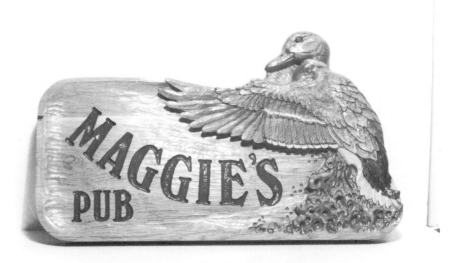

Illus. 10-32

126

# 11 *H*IGH RELIEF

Many of the same techniques used for the duck sign (Chapter 10) are used for high relief work. Mentally, however, it is necessary to keep track of numerous layers of patterns and organize the interaction of each layer of carving as the work progresses. Two methods are described here. The first starts with a solid block of wood and minimal patterns. The second utilizes a carefully worked out pattern to pre-cut each layer of wood, saving a considerable amount of time and material.

A very basic sketch was drawn for this pattern, beginning with an ellipse outline (Illus. 11-1). This church sculpture utilizes the grape leaves and trellis to form a protective spiritual and physical cover for the body of the church, represented by the lamb. The glue-up procedure was considerably complex (Illus. 11-2). A 1-inch layer, two full 2-inch layers and an additional 1-inch layer for the lamb had to be edge- and face-glued together at the same time. The pattern essentially outlined areas where larger masses of wood were needed and several areas which would be pierced through to the back.

The 1-inch layer was used on the bottom from which the trellis would be carved. This separate layer made it easier to locate the trellis while carving down into the 4 inches of oak above it. The glued-up block of red oak weighed a little over 250 pounds (Illus. 11-3).

Stop cuts were made around the lamb and the entire surface including the lamb was roughed out (Illus. 11-4). If the entire surface

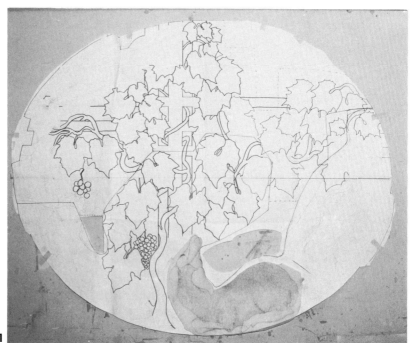

Illus. 11-1

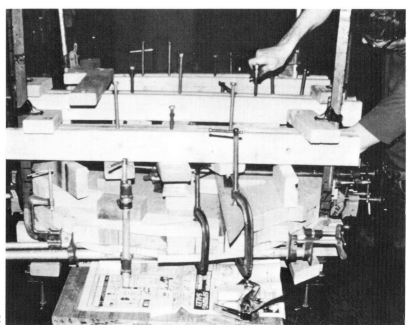

Illus. 11-2

128

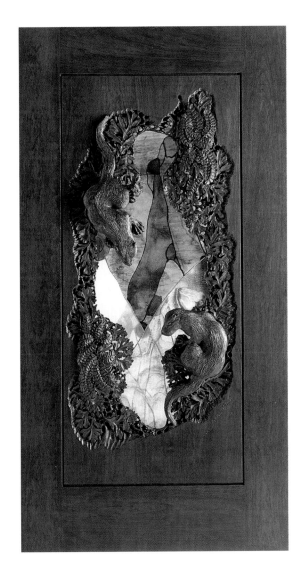

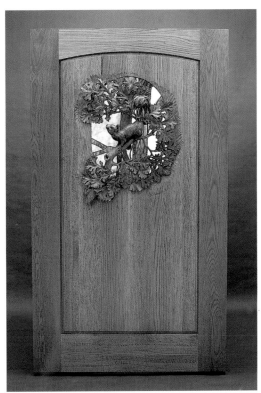

Top left: A 7' × 3'6" × 6¾" high-relief project made of cherry, stained-glass, and slice agates. This combination of wood and glass represents a small stream with river otters playing in it. Photo courtesy of Tom O'Neal. Top right: This scene of a black squirrel in an oak tree was a common sight to its owners, who live in Tennessee. It is 7" × 4" × 2" and is made of white oak and stained glass.

Right: Detail of the panel.

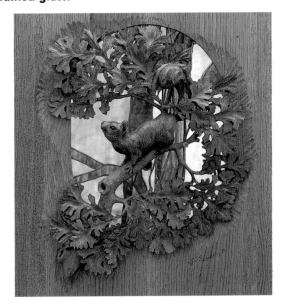

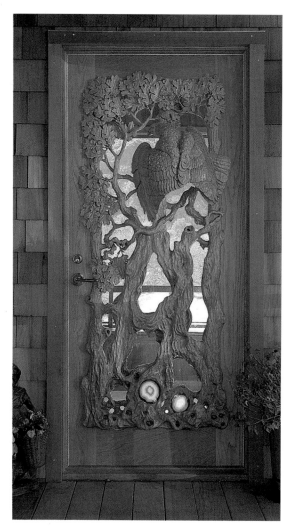

A 7' × 3' × 6" white oak door. Oak trees, red-tailed hawks, and other elements of a landscape which surround a renovated farmhouse were used for this front door.

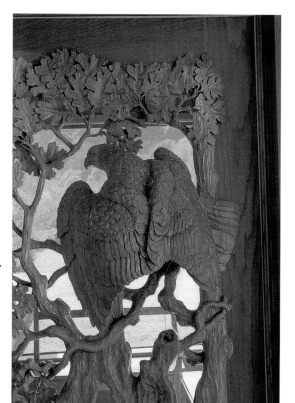

Detail of the door.

B

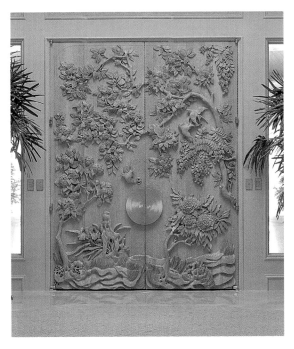

A 9' × 7' × 9" panel made of limed white oak and featuring custom brass pulls. It features an 18th-century Chinese motif that is carved on both sides. Photo courtesy of Tom O'Neal.

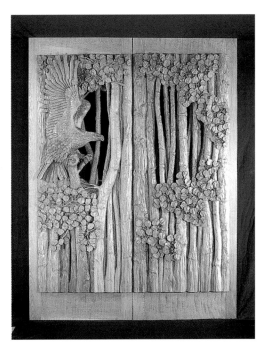

A 7' × 6' × 11" white oak door with one-half-width bronze-tinted glass. This door was featured in *Architectural Digest* in August, 1987. Photo courtesy of Tom O'Neal.

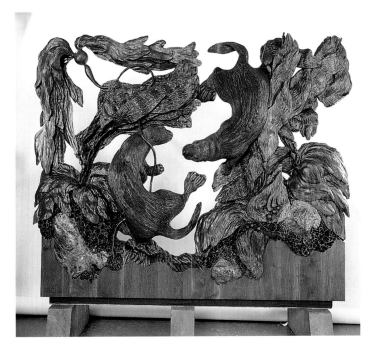

A 5' × 6' × 10" walnut and Monterey jade panel featuring sea otters and kelp. Photo courtesy of Tom O'Neal.

**Thirty-two-inch-diameter × 8-inch white oak *Flight of Life* winnowing basket.**

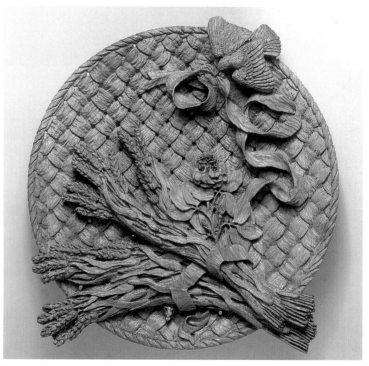

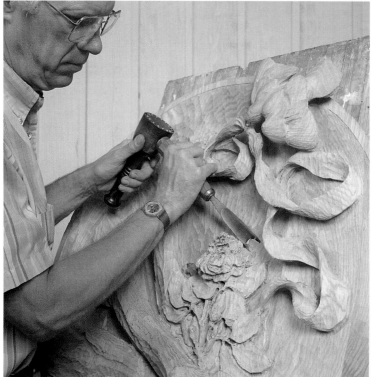

**Detail of carving process.**

D

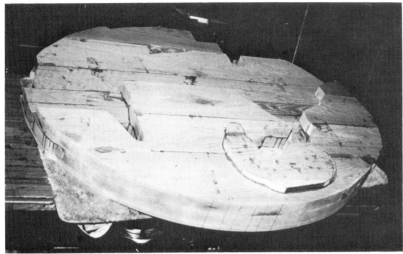

**Illus. 11-3**

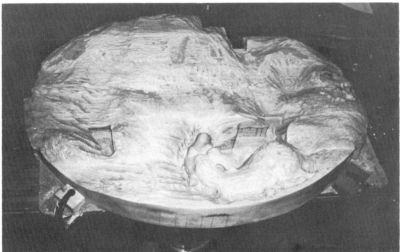

**Illus. 11-4**

of the block is not textured and contoured at this time, the subsequent pattern layout and carving on a level surface will give the finished work a flat and undesirable appearance.

Cardboard patterns, recut after each use, were arranged and traced on the wood (Illus. 11-5 & 6). Each area of foliage on the top surface emanated from below and interacted with or dissappeared back into an unfinished surface. After stop cuts were made around the patterns, the background reduced, and the remaining surfaces carved and textured, the bottom was continued into the next layers and the process repeated until the trellis or table top was reached (Illus. 11-7).

The final texture was drawn and cut into the lamb, this detail

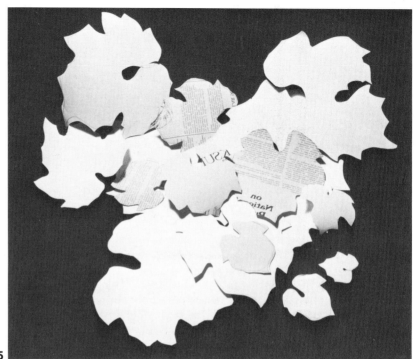

Illus. 11-5

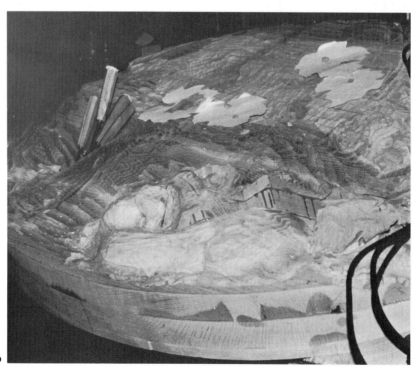

Illus. 11-6

130

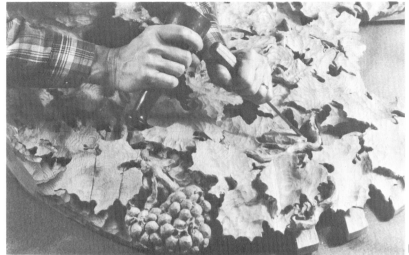
Illus. 11-7

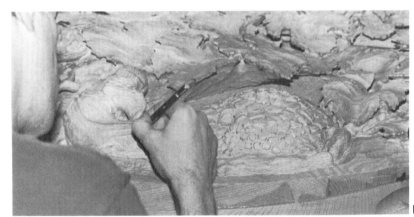
Illus. 11-8

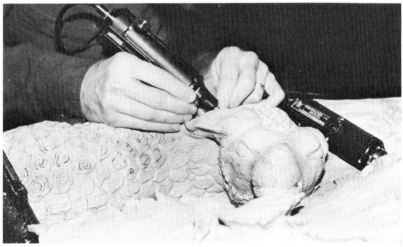
Illus. 11-9

131

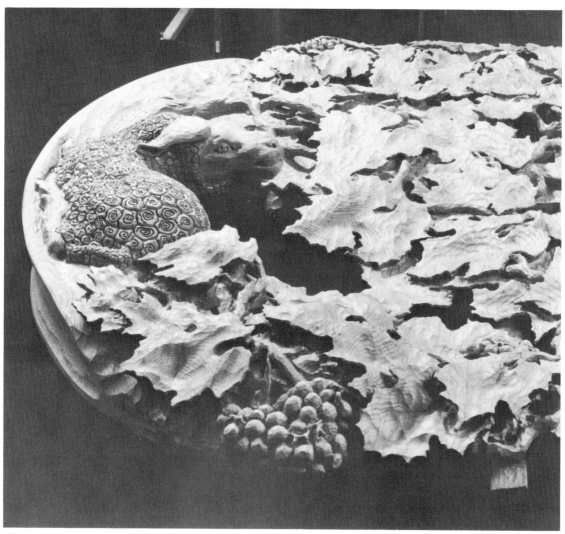

**Illus. 11-10**

chosen to be the last step to complete the carving (Illus. 8 & 9). A side view shows the pattern layering, undercutting and depth of the carving (Illus. 11-10).

This type of carving, a large block of wood and minimal patterns which allow ideas to go directly into wood, is the most satisfying work possible. But it is difficult to predict the time required and therefore estimate its cost. There are no short cuts and stopping places when time or money runs out. The mental gymnastics and actual carving were easy compared to the financial difficulties created because it took double the time allocated to this project.

A second method of preparation lessens the problems of time estimation because the final concept is better visualized and less intricate. A good working pattern is developed and each layer is pre-cut to rather close tolerances, a procedure which can result in considerable savings of time and materials.

Sketches were made (Illus. 11-11) to show the owner of a Mexican restaurant an idea for a sign which incorporated an eagle, the national bird of Mexico, with a bright chromatic range of colors presented as a mosaic, a characteristic of Mexican art, all carved out of 8 inches of red oak. Knowing exactly what the project will look like and describing it in two dimensions on paper is difficult. It was intended that the sign also be a medallion, conforming, but not confined to an ellipse.

A full-sized pattern was drawn and the wood for each layer numbered, similar to a topographical map (Illus. 11-12). Each layer had to be cut out from boards surfaced and jointed for edge- and face-gluing (Illus. 11-13 to 15). It was important that each layer could be clamped together to insure tight edge-joints. The cut out areas helped minimize weight and to equalize some stress caused by gluing together such large panels of wood.

Because the clamping of each layer had been thought out beforehand, the final glue-up (Illus. 11-16) using marine epoxy, was relatively simple. The resulting block represents about 150 pounds of red oak (Illus. 11-17).

Nothing is faster at making an indoor mess than a chain saw, but it also makes quick work of eliminating the step effect caused by layering (Illus. 11-18).

Contouring and establishing the basic shapes and forms can

**Illus. 11-11**

133

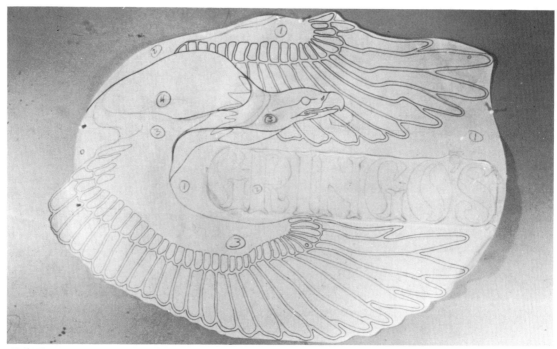

Illus. 11-12

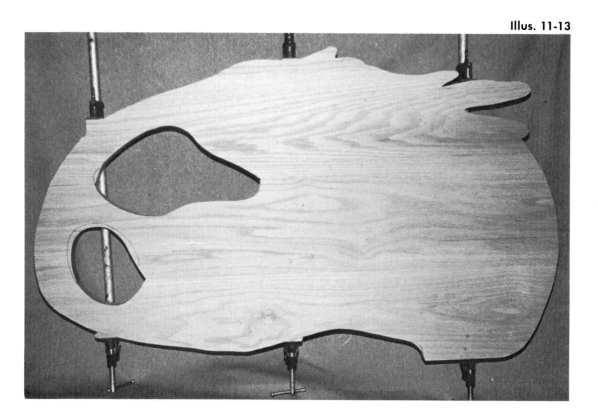

Illus. 11-13

134

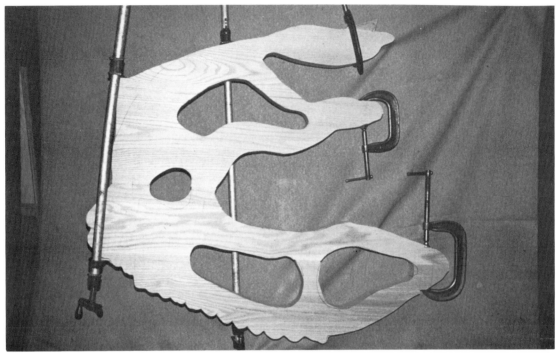

Illus. 11-14

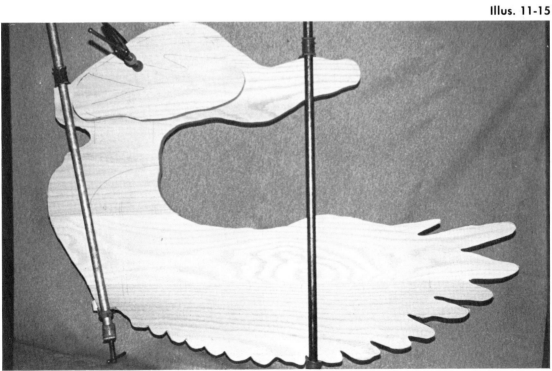

proceed rapidly with the use of pneumatic die grinders with large diameter ball mills (Illus. 11-19) and the mallet with large gouges (Illus. 11-20). It took less than a day to go from Illus. 11-19 to what is depicted in Illus. 11-21 which has the head (Illus. 11-22), body and background complete. The wings are ready for finish work.

After the back wing was completed the front wing detail was drawn out in pencil (Illus. 11-23). The concave areas for color were carved and shaped with gouges and small burrs (Illus. 11-24) and the completed carving was ready for its nameboard, finish and color (Illus. 11-25). A clear exterior polyurethane was used because the sign was to be mounted under an awning away from direct sunlight.

Illus. 11-16

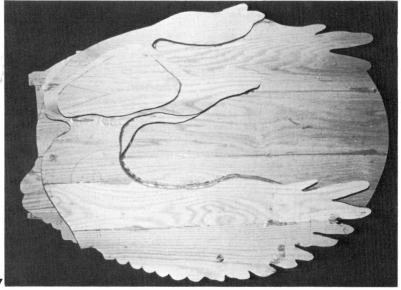

Illus. 11-17

136

Illus. 11-18

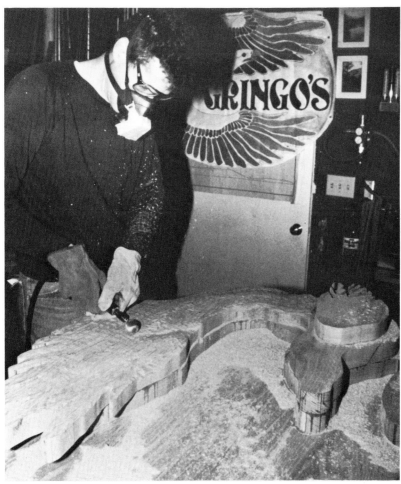

Illus. 11-19

137

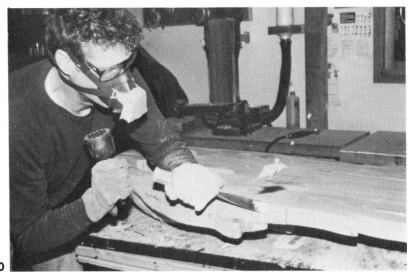

Illus. 11-20

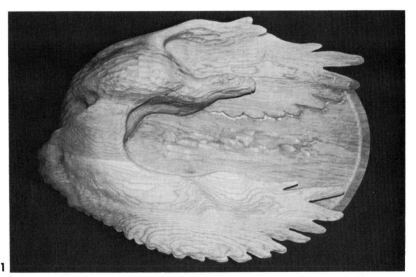

Illus. 11-21

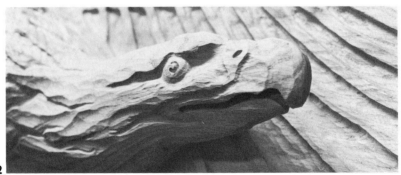

Illus. 11-22

138

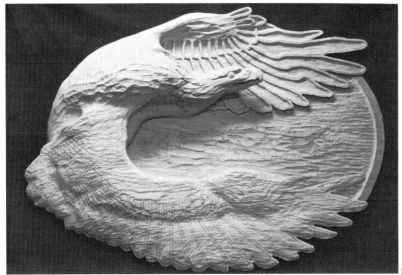

Illus. 11-23

Illus. 11-24

Illus. 11-25

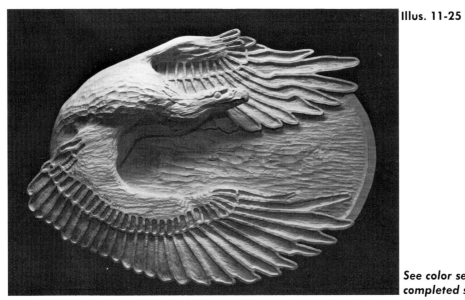

*See color section for completed sign.*

# 12 *T*HE MISSISSIPPI RIVER BANK

A commission afforded the exploration of a favorite subject, the interface between land, air and water in a cross-section of an undercut Mississippi River bank. The carving was to be a dividing panel between a long hallway and waiting room and offered an opportunity to design with backlighting from windows and frontlighting provided by skylights, which suggested stained glass and thin sections of geodes be included.

After numerous field trips and the accumulation of old and new materials (Illus. 12-1) a mental picture was developed as to the appearance of the final carving. Working backward from this image, a system was formulated to carve the piece.

It was neither possible nor necessary to develop any sort of pattern to work from and the project was as much a mental exercise as it was a carving experience. Because of its size, 5 × 7 feet, and its thickness, almost 8 inches, and because several layers of glass were to be included, four large panels of red oak were edge-glued with epoxy (Illus. 12-2). The front and back panels, braced together to insure flatness during glue-up, were larger than the two middle panels. The combined weight of the four panels was over 740 pounds.

The panels were stacked after cure and, starting with the top layer, general areas of wood for carving outlined and starter holes drilled for the saber saw which was to be used to cut out excess wood.

Illus. 12-1

Illus. 12-2

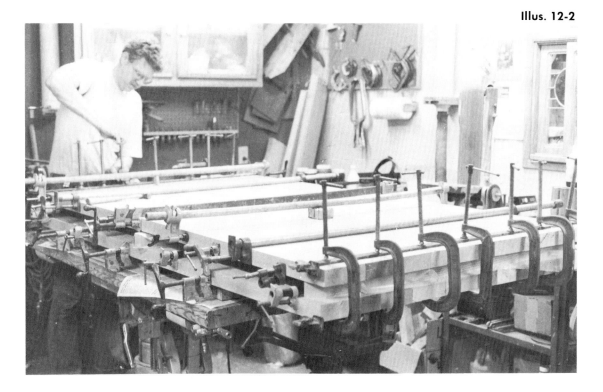

141

Illus. 12-3. Front panel.

142

Illus. 12-4. Back panel.

Illus. 12-5. Second layer.

143

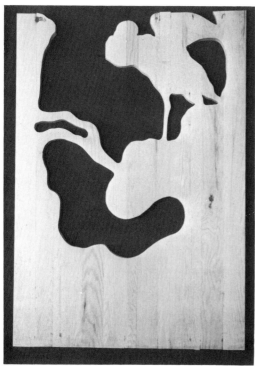

Illus. 12-6. Third layer.

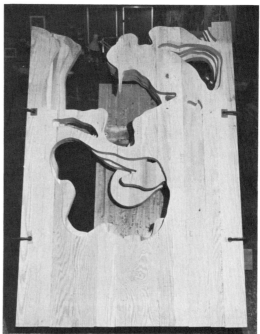

Illus. 12-7. Stacked and clamped together, several hundred pounds had been removed and the general shape was defined.

Illus. 12-8

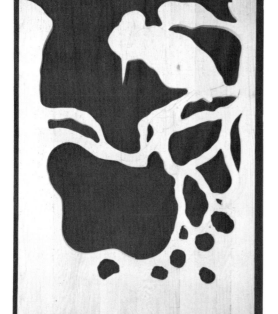

Illus. 12-9

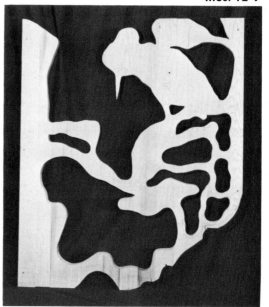

144

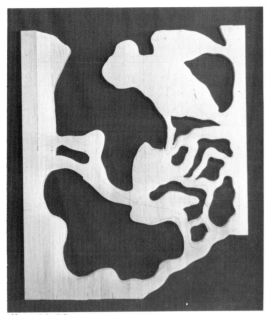

Illus. 12-10

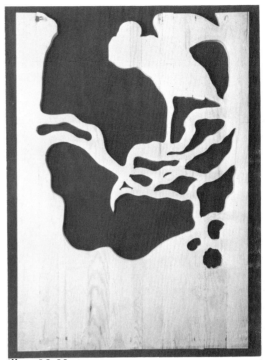

Illus. 12-11

Illus. 12-13

Illus. 12-12

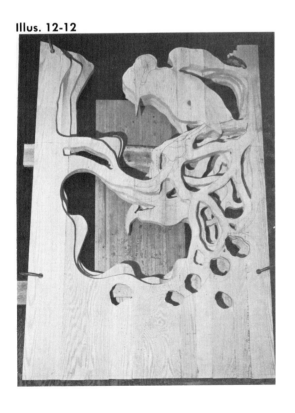

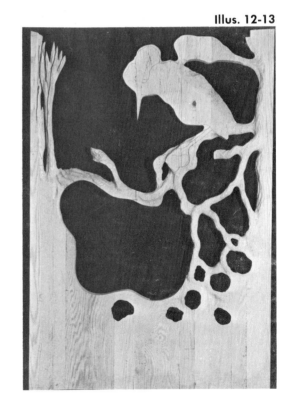

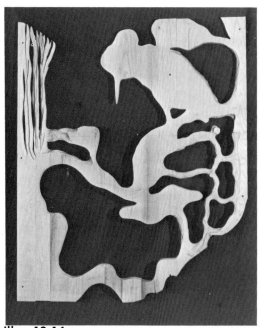

Illus. 12-14

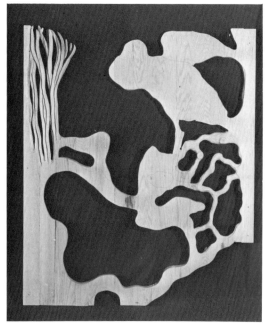

Illus. 12-15

Illus. 12-16

Illus. 12-17. The project reassembled and clamped.

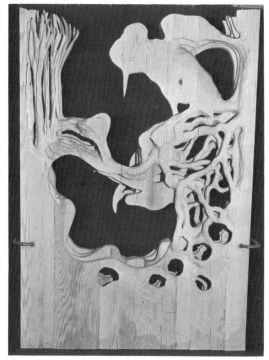

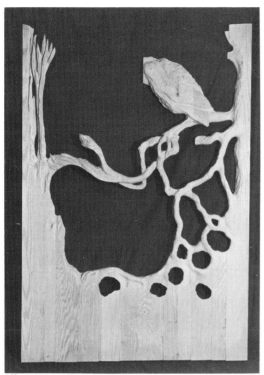

Illus. 12-18

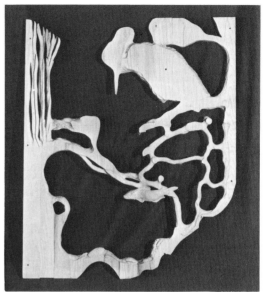

Illus. 12-19

Illus. 12-20

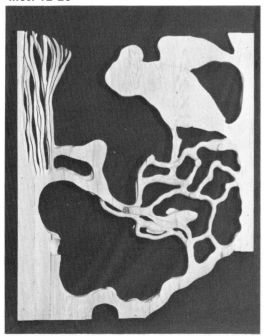

Illus. 12-21

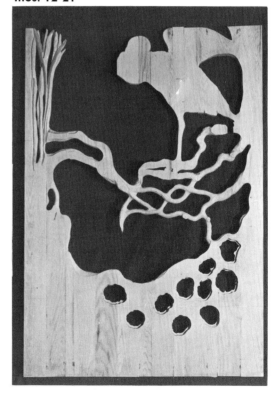

This was done for each layer and the preliminary cutouts were made. A root system with cutouts to match specific stone sections, and wood for the catfish was defined (Illus. 12-8 to 12-11) and the panels were stacked and checked for continuity between layers and for design development (Illus. 12-12). Each layer required a pattern charcoaled onto the surface of the wood, excess wood removed, turning over and the pattern continued onto the next panel. Much of

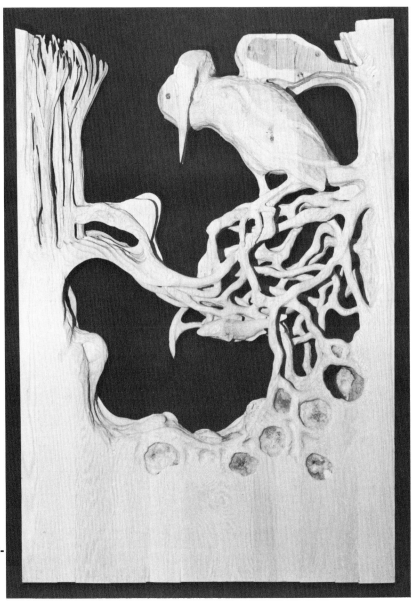

**Illus. 12-22. The final assembly before the two middle panels were glued together.**

the shaping has been done, the cattails carved, the root system well defined and each section of stone routed in from the back side of each of the front and back panels (Illus. 12-13–16). The heron could not be carved until all panels were glued together.

Some roughing out was done on the heron, a part of the head went into the second panel and therefore was separated at this stage (Illus. 12-18 to 12-21).

Detail work on the catfish was begun. Most of the sliced rock was glazed in place with silicone adhesive and the panels became very fragile to move. Because the glass was to fit between each layer of wood, it was necessary to rout a $3/16$ inch space from the adjoining surfaces of the middle panels (Illus. 12-23).

To avoid breakage during delivery, the slots for the glass were routed so each section of glass could be withdrawn and reinserted from the sides after all four panels were glued together. After assuring adequate clearance for the middle sections of glass, the two middle panels were glued together with epoxy (Illus. 12-24).

Details of the carving which could not be reached after all panels were glued together were completed (Illus. 12-25) and the remaining stones inserted (Illus. 12-26). Slots for glass between the front panel and middle section and the back panel and middle section were routed and the glass cut to fit, making sure it could be removed easily before the front and back panels were glued together (Illus. 12-27 & 12-28).

The final carving and detailing could now proceed, making sure that transitions from each layer were smooth-flowing and that the glass could be removed with ease (Illus. 12-29 to 12-31). Oak was fitted into the edge openings to give the appearance of a solid, 8-inch-thick panel of wood and the entire project given four coats of flat polyurethane.

**Illus. 12-23**

149

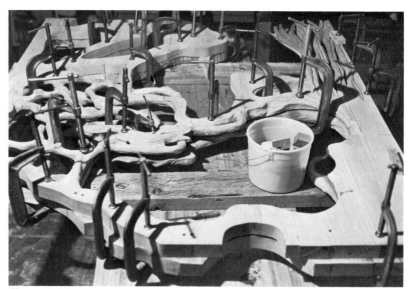

Illus. 12-24

Illus. 12-25

150

Illus. 12-26

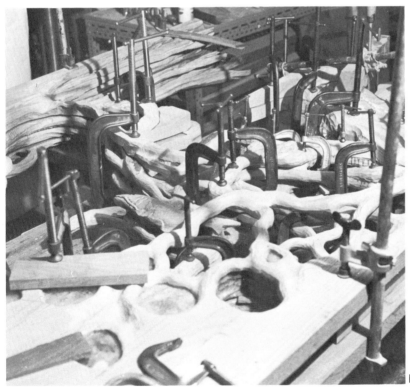

Illus. 12-27

151

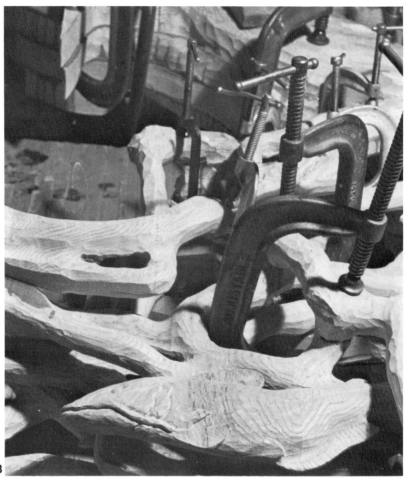

Illus. 12-28

Illus. 12-29

152

Illus. 12-30

Illus. 12-31

153

# WEIGHTS AND MEASURES

| UNIT | ABBREVIATION | EQUIVALENTS IN OTHER UNITS OF SAME SYSTEM | METRIC EQUIVALENT |
|---|---|---|---|
| **Weight** | | | |
| *Avoirdupois* | | | |
| ton | | | |
|   short ton | | 20 short hundredweight, 2000 pounds | 0.907 metric tons |
|   long ton | | 20 long hundredweight, 2240 pounds | 1.016 metric tons |
| hundredweight | cwt | | |
|   short hundredweight | | 100 pounds, 0.05 short tons | 45.359 kilograms |
|   long hundredweight | | 112 pounds, 0.05 long tons | 50.802 kilograms |
| pound | lb *or* lb av *also* # | 16 ounces, 7000 grains | 0.453 kilograms |
| ounce | oz *or* oz av | 16 drams, 437.5 grains | 28.349 grams |
| dram | dr *or* dr av | 27.343 grains, 0.0625 ounces | 1.771 grams |
| grain | gr | 0.036 drams, 0.002285 ounces | 0.0648 grams |
| *Troy* | | | |
| pound | lb t | 12 ounces, 240 pennyweight, 5760 grains | 0.373 kilograms |
| ounce | oz t | 20 pennyweight, 480 grains | 31.103 grams |
| pennyweight | dwt *also* pwt | 24 grains, 0.05 ounces | 1.555 grams |
| grain | gr | 0.042 pennyweight, 0.002083 ounces | 0.0648 grams |
| *Apothecaries'* | | | |
| pound | lb ap | 12 ounces, 5760 grains | 0.373 kilograms |
| ounce | oz ap | 8 drams, 480 grains | 31.103 grams |
| dram | dr ap | 3 scruples, 60 grains | 3.887 grams |
| scruple | s ap | 20 grains, 0.333 drams | 1.295 grams |
| grain | gr | 0.05 scruples, 0.002083 ounces, 0.0166 drams | 0.0648 grams |
| **Capacity** | | | |
| *U.S. Liquid Measure* | | | |
| gallon | gal | 4 quarts (2.31 cubic inches) | 3.785 litres |
| quart | qt | 2 pints (57.75 cubic inches) | 0.946 litres |
| pint | pt | 4 gills (28.875 cubic inches) | 0.473 litres |
| gill | gi | 4 fluidounces (7.218 cubic inches) | 118.291 millilitres |
| fluidounce | fl oz | 8 fluidrams (1.804 cubic inches) | 29.573 millilitres |
| fluidram | fl dr | 60 minims (0.225 cubic inches) | 3.696 millilitres |
| minim | min | 1/60 fluidram (0.003759 cubic inches) | 0.061610 millilitres |
| *U.S. Dry Measure* | | | |
| bushel | bu | 4 pecks (2150.42 cubic inches) | 35.238 litres |
| peck | pk | 8 quarts (537.605 cubic inches) | 8.809 litres |
| quart | qt | 2 pints (67.200 cubic inches) | 1.101 litres |
| pint | pt | ½ quart (33.600 cubic inches) | 0.550 litres |
| *British Imperial Liquid and Dry Measure* | | | |
| bushel | bu | 4 pecks (2219.36 cubic inches) | 0.036 cubic metres |
| peck | pk | 2 gallons (554.84 cubic inches) | 0.009 cubic metres |
| gallon | gal | 4 quarts (277.420 cubic inches) | 4.545 litres |
| quart | qt | 2 pints (69.355 cubic inches) | 1.136 litres |
| pint | pt | 4 gills (34.678 cubic inches) | 568.26 cubic centimetres |
| gill | gi | 5 fluidounces (8.669 cubic inches) | 142.066 cubic centimetres |
| fluidounce | fl oz | 8 fluidrams (1.7339 cubic inches) | 28.416 cubic centimetres |
| fluidram | fl dr | 60 minims (0.216734 cubic inches) | 3.5516 cubic centimetres |
| minim | min | 1/60 fluidram (0.003612 cubic inches) | 0.059194 cubic centimetres |
| **Length** | | | |
| mile | mi | 5280 feet, 320 rods, 1760 yards | 1.609 kilometres |
| rod | rd | 5.50 yards, 16.5 feet | 5.029 metres |
| yard | yd | 3 feet, 36 inches | 0.914 metres |
| foot | ft *or* ' | 12 inches, 0.333 yards | 30.480 centimetres |
| inch | in *or* " | 0.083 feet, 0.027 yards | 2.540 centimetres |
| **Volume** | | | |
| cubic yard | cu yd *or* yd³ | 27 cubic feet, 46,656 cubic inches | 0.765 cubic metres |
| cubic foot | cu ft *or* ft³ | 1728 cubic inches, 0.0370 cubic yards | 0.028 cubic metres |
| cubic inch | cu in *or* in³ | 0.00058 cubic feet, 0.000021 cubic yards | 16.387 cubic centimetres |

# METRIC SYSTEM

| UNIT | ABBREVIATION | | APPROXIMATE U.S. EQUIVALENT |
|---|---|---|---|
| **Length** | | | |
| | | *Number of Metres* | |
| myriametre | mym | 10,000 | 6.2 miles |
| kilometre | km | 1000 | 0.62 mile |
| hectometre | hm | 100 | 109.36 yards |
| dekametre | dam | 10 | 32.81 feet |
| metre | m | 1 | 39.37 inches |
| decimetre | dm | 0.1 | 3.94 inches |
| centimetre | cm | 0.01 | 0.39 inch |
| millimetre | mm | 0.001 | 0.04 inch |
| **Area** | | | |
| | | *Number of Square Metres* | |
| square kilometre | sq km *or* km² | 1,000,000 | 0.3861 square miles |
| hectare | ha | 10,000 | 2.47 acres |
| are | a | 100 | 119.60 square yards |
| centare | ca | 1 | 10.76 square feet |
| square centimetre | sq cm *or* cm² | 0.0001 | 0.155 square inch |

## Volume

| UNIT | ABBREVIATION | | APPROXIMATE U.S. EQUIVALENT |
|---|---|---|---|
| | | *Number of Cubic Metres* | |
| dekastere | das | 10 | 13.10 cubic yards |
| stere | s | 1 | 1.31 cubic yards |
| decistere | ds | 0.10 | 3.53 cubic feet |
| cubic centimetre | cu cm *or* cm³ *also* cc | 0.000001 | 0.061 cubic inch |

## Capacity

| UNIT | ABBREVIATION | Number of Litres | Cubic | Dry | Liquid |
|---|---|---|---|---|---|
| kilolitre | kl | 1000 | 1.31 cubic yards | | |
| hectolitre | hl | 100 | 3.53 cubic feet | 2.84 bushels | |
| dekalitre | dal | 10 | 0.35 cubic foot | 1.14 pecks | 2.64 gallons |
| litre | l | 1 | 61.02 cubic inches | 0.908 quart | 1.057 quarts |
| decilitre | dl | 0.10 | 6.1 cubic inches | 0.18 pint | 0.21 pint |
| centilitre | cl | 0.01 | 0.6 cubic inch | | 0.338 fluidounce |
| millilitre | ml | 0.001 | 0.06 cubic inch | | 0.27 fluidram |

## Mass and Weight

| UNIT | ABBREVIATION | Number of Grams | APPROXIMATE U.S. EQUIVALENT |
|---|---|---|---|
| metric ton | MT *or* t | 1,000,000 | 1.1 tons |
| quintal | q | 100,000 | 220.46 pounds |
| kilogram | kg | 1,000 | 2.2046 pounds |
| hectogram | hg | 100 | 3.527 ounces |
| dekagram | dag | 10 | 0.353 ounce |
| gram | g *or* gm | 1 | 0.035 ounce |
| decigram | dg | 0.10 | 1.543 grains |
| centigram | cg | 0.01 | 0.154 grain |
| milligram | mg | 0.001 | 0.015 grain |

# ABOUT THE AUTHOR

William J. Schnute was born in Ann Arbor, Michigan in 1942, and raised in Chicago and its suburbs. A lifelong interest in wood carving culminated in the founding of the Oak Leaves studio in 1974. He has been occupied as a wood sculptor ever since. Bill lives with his children in Carmel Valley, California.

# INDEX